Barron's Art Handbooks

PORTRAITS

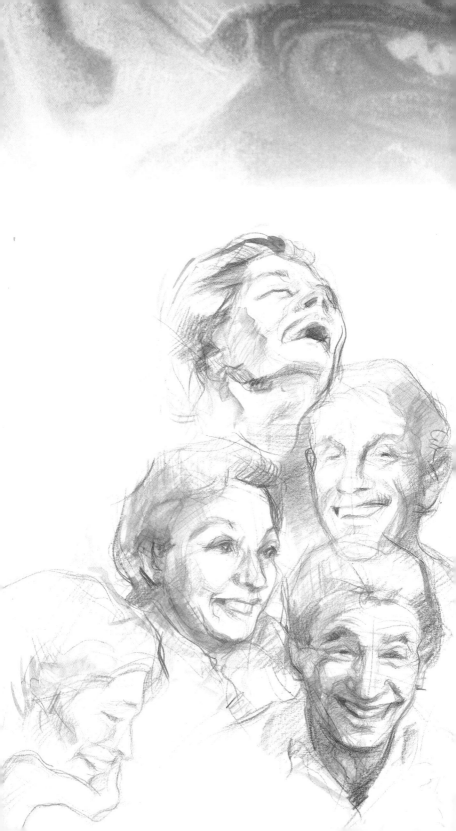

Barron's Art Handbooks

PORTRAITS

BARRON'S

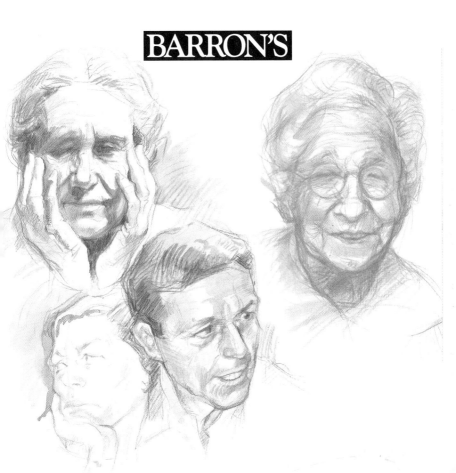

CONTENTS

EARLY MANIFESTATIONS OF THE PORTRAIT

The function of painting at the dawn of Western civilization was very different from its function in later eras. The portrait as such does not appear as a genre until the end of the Roman Empire; then, it disappears for centuries until reemerging at the beginning of the modern era. The portrait is a representation of the individual—the specific characteristics that cannot survive the test of time. Such portraits can barely exist in cultures based on symbols of eternity and the idea of the everlasting.

Ancient Egypt

Representations of people in Ancient Egyptian painting cannot really be considered portraits. Rather, they are archetypes of social figures surrounded by the attributes of their role—their social power, and their function within the state. What has been preserved from this type of work comes from tombs and funeral chambers. The portrait in Ancient Egypt has a religious function; its aim is the continued existence of the embalmed person beyond death. Pictorial representations, as symbols of survival of the soul, are designed to guarantee this survival. Faces follow a formula that is very beautiful and completely idealized. There is no trace of interest in particular characteristics or in differentiating the features of one person from all others.

Rome

The painting of Etruscan tombs probably provided the base from which Roman painting, and in particular the realistic commemorative portrait, developed. The Romans sought to conquer an entire empire and impose their way of life on others. This culture made possible the representation of the individual—above all in sculpture—with the clear intention of exalting imperial power. In painting, landscape and architectural decoration were preferred. When Roman sculpture spread to the Middle East, Imperial artists discovered a fertile field for the art of portraiture. In these portraits the religious and ceremonial tendency typical of Egyptian painting mixed with such realistic Greco-

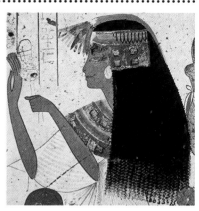

Portrait of a Lady. (3500 B.C.) Tomb of Ouserhat, Thebes. Egyptian figures are symbolic representations of important people without specific distinguishing characteristics.

Roman techniques as chiaroscuro and the depiction of the personal characteristics of the portrait's subject. When the power of the Empire began to decline and the idea of the individual appeared as a contrast to depersonalized power, the portrait flourished in early Christian art forms. The first Christians created individual portraits in the catacombs, leaving a record of their presence and affirming the personal value of human life.

The few portraits that remain from the Roman period show a great mastery of representation of features and expressions, which leads us to suppose that the portrait was in common use and that artists received regular commissions from wealthy clients.

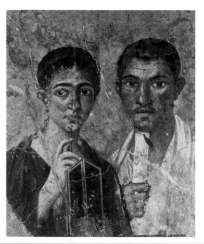

Portrait of a Magistrate and His Wife. (third century A.D.) Archaeological Museum, Naples. This rare Roman portrait painting was part of a mural decoration in a Pompeian house.

The Middle Ages

The advance of Christianity provided a new power that stabilized the Western world following the fall of the Roman Empire, the invasions of the Barbarians, and the divisions between East and West. The pope became the veritable focus of power in the Middle Ages, the new emperor. With this new Imperial power the portrait began to decline once more, giving way to generic formulas and symbols in the representation of the human figure. Among the enormous number of images produced in the Middle Ages, there are barely any portraits. Even when artists represented historical or secular themes, the people are undifferentiated—generalizations of the human figure displaying indeterminate characteristics that are impossible to ascribe to specific individuals. It was not until society lost its

Funeral Portraits

The most realistic examples of ancient portraiture come from El-Fayum in Egypt. In this Roman province commemorative portraits of the dead were painted on small panels, which were then placed on their sarcophagi in accordance with secular Egyptian tradition. These surprisingly realistic portraits show the degree of mastery the Imperial painters achieved, leading us to suppose that the practice of naturalistic portraits was much more widespread than might be suggested by the few surviving examples.

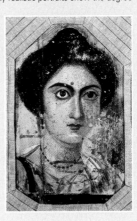

Female Portrait.
(third century A.D.)
Archaeological
Museum, Florence.
This funeral portrait from
El-Fayum, in the North of
Egypt, shows an unusual
realism more in line with
modern portraits.

hierarchic nature that the individual began to manifest itself and the portrait as we understand it appears.

Portrait of Pope John VII. *(705 A.D.)*
Vatican Museum, Rome.
Although this is a representation of an individual,
the characteristics are generalized, in common with
all figures in primitive Medieval painting.

Portrait of Emperor Otto II. *(936 A.D.)*
Condé Museum, Chantilly.
Absolute power in the Middle Ages was
represented by generic characteristics.

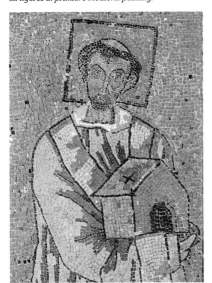

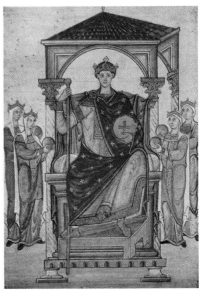

THE PORTRAIT DURING THE RENAISSANCE

The personalized portrait appears at the end of the Middle Ages, at the same time as the position of the individual emerges as a factor in human life and history. Generic representations of humanity give way to an awareness of individual characteristics. This is the beginning of the modern portrait—an approach that aims at a greater and greater realism based on a new concept of humanity and a new type of artistic sensibility.

The First Portraits

The transition from generic representations to true portraits was a long and gradual process. It is impossible to point to a moment or a work in which it first clearly occurred. Rather, the style of painters slowly incorporated more and more characteristics of the person being represented, but always within a generic formula. What really affected the new realistic tendency was the great demand for paintings that included a likeness of the person who had commissioned it: a Church official, a prince, a nobleman, or a wealthy merchant. These great patrons of the arts took pleasure in seeing themselves taking part in religious scenes and wanted the viewer to be able to recognize them alongside the images of the Virgin or the saints. This factor combined with two other facts of equal or greater importance: the new manner of representing depth (through perspective) and the introduction of oil painting. The representation of space opened the doors of realism; and oil painting, which is slow to dry and has a great capacity for detail, was the perfect complement to the new style.

Patrons

Patrons were the figures who appeared in acts of veneration with saints or in sacred scenes represented in a painting they had commissioned. It was in the figures of these patrons that the artists at the end of the Middle Ages began to create true portraits. The realism of the representations became more and more precise. Finally, the clients of the artists began to commission individual portraits that could stand alone, without the justification of a religious scene.

Renaissance Profiles

In Renaissance Italy, the portrait appears as an independent genre with a peculiar form. Many of these early portraits are busts of figures seen in profile, outlined against either a neutral background or against a landscape. The inspiration for these portraits comes from ancient Roman coins in which the representation of the emperor was stamped on one or both sides. This type of portrait possesses an incomparable pictorial grace, largely due to the elegant lines, which outline the profile and define in turn all the details of the individual's physiognomy.

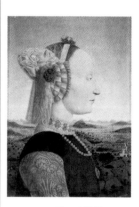

Piero della Francesca (c. 1420–1492), Portrait of Battista Sforza. Uffizi Gallery, Florence. The Renaissance introduced the profile portrait in the style of Roman coins and medallions.

Simone Martini (1285–1344), Saint Louis of Toulouse Crowning Robert of Anjou. Capodimonte Museum, Naples. At the end of the Middle Ages, the faces became more individual and the real portrait began to appear.

Realism and the Courtly Portrait

From the second decade of the fifteenth century in Italy, two great tendencies in portrait

Early Manifestations of the Portrait
The Portrait During the Renaissance
Great Portrait Painters of the Renaissance

9

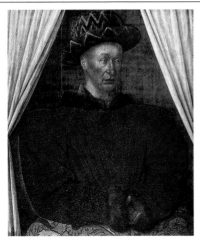

Jean Fouquet (1420–1481), Charles VII, King of France. The Louvre, Paris. This work is halfway between the new Italian realism and the Gothic tradition of the generic courtly portrait.

painting developed: one traditional and courtly, the other monumental and realistic. The courtly portrait extended the refined, decorative style of Gothic art: elegant representations of people dressed in luxurious clothing, set against a background that was either natural or richly decorated. This type of portrait took the possibilities of the evolution of medieval painting to the limit and reached its brilliant peak in this period. The realistic tendency, on the other hand, introduced a new concept of the portrait as monumental and robust, cleansed of ornamental details and with a more sober coloring. The great masters of the Renaissance and the Baroque created most of their portraits in accordance with this latter tendency.

The Flemish Portrait

Together with Northern Italy, Flanders was the great commercial power of fifteenth-century Europe. In Flanders a localized pictorial tradition developed which, along with the Italian example, would have great artistic influence on the continent. The Flemish artists painted works of a quality and originality that came to characterize the output of many notable artists of Italy itself. In Flanders, where there was no great tradition of mural painting, Flemish paintings were altarpieces or small-scale panels. These works were not designed to decorate palaces or great cathedrals, but rather to form part of bourgeois interior decoration. In Flanders the portrait found a fertile environment for its development. Flemish portraits show prodigious detail and a virtuoso technique in which each line of a face and each fold in a piece of cloth are meticulously depicted.

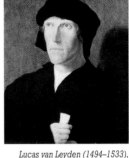

Lucas van Leyden (1494–1533), Thirty-eight-year-old Man. National Gallery, London. Flemish realism made the portrait one of the most interesting genres of the period.

The Realism of Jan van Eyck

Jan van Eyck is the great master of fifteenth century Flemish painting. He used to be considered the inventor of oil painting, although now it is known that this process was already known in Flanders. What is certain is that Van Eyck obtained from oil everything that this medium offers in the faithful representation of light, material, skin, and every other physical reality in the world. His realism, which is so minute as to be almost unbelievable, turns his scenes into microcosms, so rich in detail that they could be the subject's actual surroundings.

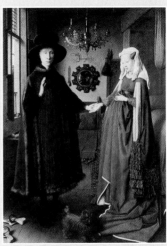

Jan van Eyck (c. 1400–1441), The Marriage of Arnolfini. National Gallery, London. This is the most famous work by Jan van Eyck. The realism achieved in it is one of the all-time peaks of portrait painting.

HISTORICAL BACKGROUND

GREAT PORTRAIT PAINTERS OF THE RENAISSANCE

During the Renaissance, Italy developed a monumental approach to the portrait. This approach is characterized by a figure isolated against a simple background, either as a bust or a full body. There is a preference for noble gestures and majestic poses that express the importance of the person being painted. This style would be adopted by the foremost Renaissance painters, who used the genre to create great masterpieces.

Leonardo Da Vinci

The relatively few portraits painted by Leonardo da Vinci have passed into history not only as masterpieces of the genre but also as supreme examples of the new way of understanding the representation of the human figure that began during the Renaissance. Of all the portraits painted by Leonardo da Vinci, the most famous beyond all doubt is the Mona Lisa. This enigmatic painting is the model for innumerable later works that were inspired by its composition and technique, as well as by the psychological suggestiveness shown in the woman's face. The technique of *sfumatto*, the diffusion of outlines, and the aerial perspective with its misty, unfocused atmosphere, reinforce this psychological ambiguity. This work also created a compositional model that would meet with

The Mannerist Portraits of El Greco

Like Titian, El Greco was a skilled portraitist. This is surprising in a mannerist painter, that is to say one whose highly individual style was a long way from realism and prone to exaggeration and distortion. It is impossible to judge to what extent his portraits resembled their subjects, but the expressive power and intense spirituality that his figures emanate show the painter to be a psychological portraitist of the highest order.

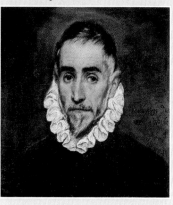

El Greco (1541–1614), Nobleman. The Prado, Madrid. El Greco's mannerist style manifests itself in disfigurations and distortions of the face, stylizing their shape and giving his subjects an undeniable psychological impact.

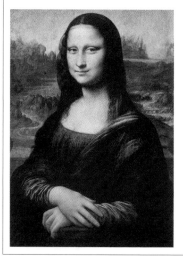

Leonardo da Vinci (1452–1519), Mona Lisa. The Louvre, Paris. This is one of the works that heralded the new style of monumental Renaissance portraiture. The technical innovations of this painting would have an effect on all the styles of Europe.

universal approval: a three-quarter view of a sitter with hands crossed, against the background of a landscape. All these stylistic and expressive factors would be imitated

almost immediately by many portrait painters; while Leonardo's interest in caricature and the study of physiognomy would not become fully evident in art until several centuries later.

Raphael

Following Leonardo's example, Raphael established the definitive model for the classical portrait. The composition of this type of portrait is arranged in the form of a pyramid, which sits squarely on the base of the painting and rises to the head of the subject. Generous forms, clear, simple profiles, and the absence of unnecessary detail create a serene, monumental effect. Raphael's portraits became

The Portrait During the Renaissance
Great Portrait Painters of the Renaissance
The Golden Age of the Portrait

11

the standard model for all painters aiming at classical harmony, both in the Renaissance and in all later periods.

Albrecht Dürer and the Self-portrait

The training of this German painter was based on the Gothic traditions of his country, but his visits to Italy and his tireless study of Italian art made him a keen champion of new ideals in the representation of the human form. Dürer's best paintings are probably the ones that escape from his desire to capture and disseminate Italian theory—his studies of nature in landscapes and in simple paintings of plants and animals, but above all in his portraits and self-portraits. Dürer was one of the pioneers of the self-portrait. This fact shows a new tendency in art and a clear awareness of the importance of the artist. Following in Leonardo's steps, Dürer champions the nobility of painting and the superiority of the painter above the simple craftsmen. If painting is to represent the most worthy themes, then the self-portrait represents a declaration of the dignity of the artist.

The Venetian Masters

The Italian Renaissance achieved its most splendid expression in sixteenth-century Venice. The three most notable Venetian painters (Titian, Tintoretto, and Veronese) are great portraitists who received commissions from all the courts of Europe. The process of affording the artist greater dignity reached its apogee at this time. The Emperor bestowed a noble title on Titian and declared himself an admirer of his art. Titian's success was incomparably greater than that of any previous artist. This success

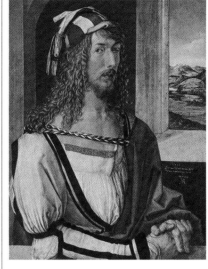

Albrecht Dürer (1471–1528), Self-portrait. The Prado, Madrid. Dürer's self-portraits were pioneers of the genre. The artist sees himself as comparable to the usual subjects of portraits of this period.

was due not least to his portraits: they are incredibly clear and lively works in which the characters seem to hold no secrets from the painter. They retain their classical monumentality and to this is added a powerful feel for color, which would obsess all his followers.

Titian (c. 1487–1576), Portrait of Federico II de Gonzaga. The Prado, Madrid. The monumentality of the design and the strength of the color are unmistakable marks of Titian's style.

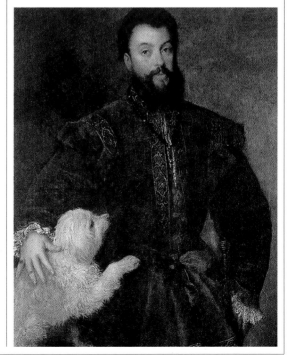

MORE ON THIS SUBJECT

- The Portrait During the Renaissance **p.8**
- Self-portraits **p.46**
- Pose **p.50**

HISTORICAL BACKGROUND

THE GOLDEN AGE OF THE PORTRAIT

During the Baroque period, the portrait became fully established as a pictorial genre and enjoyed a wide popularity. The courts of Europe had official portraitists. Nobles and wealthy bourgeois alike wanted their portraits painted. The flourishing of the genre is evident not only from the great number of famous portraits that were painted during this period but also from the fact that the most outstanding masterpieces painted by the geniuses of the period were in fact portraits.

Rubens

Rubens was the most extrovert and passionate of the Baroque painters. After Titian he was the most famous, the most wealthy, and easily the most prolific of painters. His speciality was large-scale allegorical compositions, which he created with the collaboration of his helpers and to which he only contributed summarily. Apparently he did not value the portrait; Rubens considered it a lower genre, and he only painted a few "in order to get more important work." However, it is in his portraits (many of them of his wife and children) that Rubens is at his most direct and expressive, freed from the rhetorical weight of his large, decorative compositions. For the viewer today, Rubens' portraits are probably the most attractive element of his work, because of their synthesis of form and color, the freshness with which he created them, and the tenderness of his representations of his loved ones.

Velázquez

At the age of 23, Velázquez became the most important painter at the court of Phillip IV. Velázquez shared Ruben's opinion of portraits and did not consider himself a portraitist. Nevertheless, he created a large number of portraits of members of the court—from the King to the jesters, from the princesses to the chambermaids. He managed to make these magnificent paintings come to life, while at the same time his

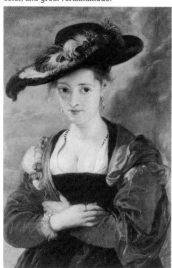

Rubens (1577–1640), Susana Lunden. *National Gallery, London. Rubens portraits are paintings full of life, freshness of color, and great verisimilitude.*

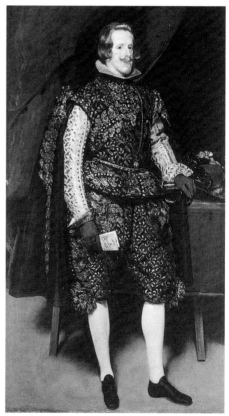

Velázquezs (1599–1660), Phillip IV of Spain. *National Gallery, London. Combining the influence of the Venetian painters and of Rubens, Velázquez created a masterful style, which he used to create portraits that are outstanding for their objectivity.*

Great Portrait Painters of the Renaissance 13
The Golden Age of the Portrait
New Visions of the Portrait: The Romantic Portrait

style of painting them was evolving. Velázquez progressed from realism using chiaroscuro to a style based on color that he probably borrowed from the Venetians. Brush strokes became finer and more separated, color is smooth and soft, shapes are seen in synthesis, and the brushwork anticipates Impressionism. The effect of Velázquez's portraiture is one of supreme objectivity, free from sentimental or rhetorical stylization. For this reason he is considered by many to be the greatest portraitist of all time.

Frans Hals and Rembrandt

When Holland freed itself from Spanish rule it became an independent country, Protestant and mercantile. It was a country that loved all painting other than large, rhetorical, Catholic compositions. Frans Hals and Rembrandt, the great portrait painters of seventeenth-century Holland, produced an enormous number of portraits for their bourgeois clients. Hals specialized in group portraits—which had become fashionable in Holland—paid for by military companies or councils and assemblies of diverse institutions. In addition to this, Hals painted a large number of portraits of individuals or couples for the wealthy merchants and industrialists of Haarlem, his native city. However, Frans Hals, who loved portraits,

Rembrandt, the Genius of the Self-portrait

Rembrandt left approximately 60 self-portraits, stretching from his youth to his final days. These works provide an exceptional record of his technical and personal development. The portraits of his youth are very lively, with powerful chiaroscuro that theatrically accentuates the arrogant pose and gesture of the painter. In his maturity, Rembrandt's self-portraits become more majestic and his technique more certain and detailed, while in his old age the painter did not spare any detail in the representation of his physical decline, which he painted with a rich, golden light.

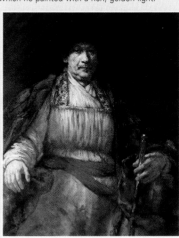

Rembrandt (1606–1669), Self-portrait. Frick Collection, New York. This is one of about 60 surviving self-portraits by Rembrandt. This series, which covers the entire life of the painter, is the most important collection of self-portraits in the history of art.

also painted a large number of more humble people for the pure pleasure of it. Distinct from his huge commercial output, these portraits reveal great inventiveness and originality combined with supreme pictorial qualities. Never before had gestures and facial expressions been represented with such verisimilitude and immediacy. His strict realism, moti-

vated by his sympathy for the subjects of his portraits, was executed with a surprising brush technique that approaches Impressionism.

Rembrandt is beyond doubt the most famous Dutch painter of all time. No other painter ever achieved the matchless emotional depth with which Rembrandt managed to infuse his portraits, to the point that even the characters in his biblical scenes move the viewer with the humanity of the drama they represent. Technically he is the great master of chiaroscuro, impasto colors, and deep tones. With Rembrandt, light becomes a resource for the psychological expression of the subject's personality.

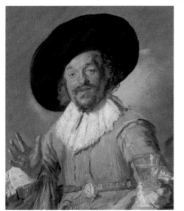

Frans Hals (c. 1580–1666), The Happy Drinker. The Louvre, Paris. Rijksmuseum, Amsterdam. Apart from commissioned portraits, Frans Hals painted a great number of portraits of humble people in spontaneous poses. The vitality of the expressions, the spontaneity of the poses, and the energy of the brushwork transform these works into masterpieces of the genre.

MORE ON THIS SUBJECT

· Great Portrait Painters of the Renaissance **p.10**
· Group Portraits **p.48**
· Illuminating the Portrait **p. 58**

NEW VISIONS OF THE PORTRAIT: THE ROMANTIC PORTRAIT

The eighteenth century witnessed a great flourishing of the courtly portrait. The French court was the political center of Europe and the painters of the nobility specialized in filling their work with richness and opulence in order to exalt the status of the king and his circle. Simultaneously, the opposite tendency was developing outside the court: intimate, psychological bourgeois portraits that expressed sentimentality and romantic passion.

France in the Eighteenth Century

French courtly painting specialized in official portraits. These were portraits designed to reveal the rank of the subject by means of various accessories in the painting (clothing, instruments, furniture, headwear, and so on) that indicated the profession and social position of the client. Thus, the official French portrait was a display of ostentation.

When Maurice Quentin de la Tour chose to use pastels as his only medium, he distanced himself from academic painting, which gave primacy to oils. He

Maurice Quentin de la Tour (1704–1788), Self-portrait. *Antoine Lécuyer Museum, San Quentin. La Tour had a sharp capacity for capturing the subtleties of the person being painted.*

also distanced himself by adopting another new characteristic that was unique to the eighteenth century: an interest in the personality of the individual, the subtle revelation of significant expressions such as malice, intelligence, cunning, charm—all those aspects that are summed up when talking about the *soul* of the subject. The soul rather than the social position was what interested de la Tour; he was equally capable of painting the portrait of an aristocrat as of a postman, so long as he felt the subject had an interesting personality.

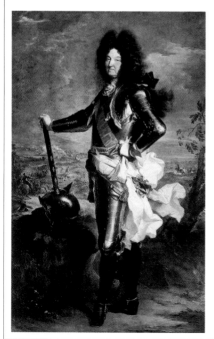

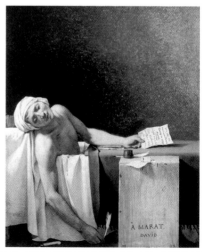

Hyacinthe Rigaud (1649–1743), Louis XIV. *The Prado, Madrid. This is an example of courtly portraiture at the point when the French monarchy was at its most splendid.*

Jacques-Louis David (1748–1825), The Death of Marat. *Museum of Fine Art, Brussels. David's portraits exemplify the artists of the French Republic.*

The Golden Age of the Portrait 15
New Visions of the Portrait: The Romantic Portrait
Impressionist Portraits

Neoclassicism: David

The real problem of portraiture was not faced clearly and definitively until almost the nineteenth century. At this point in painting's history attempts were made to find answers to questions that had frequently arisen in the minds of the artist and client when considering portraiture: is it a truly noble genre? Is there artistic value in portraits of the poor, the old, or the marginalized? Do portraits have any kind of moral message or significance? The French revolution marks the beginning of a new era for all aspects of social, political, and economic affairs. New answers appeared to age-old questions. The first came from a painter who had himself been involved in the Revolution: Jacques-Louis David. David favored a return to classicism, which he considered pure, sincere, and morally worthy. He believed in portraits of individuals who could provide models of behavior—portraits that would be educational for the people. Behind the form of Neoclassicism lay a new ideology: a romantic attitude and a faith in the moral elevation of man through art.

Ingres' Teaching

Ingres' teachings, some of which appear below, are important for understanding the artistic thoughts of the great portrait painter, as well as for the important lessons they teach.
- The painter should search for the model's character.
- Study the poses that are customary for each age group.
- No two people resemble one another.
- A good painter must penetrate the spirit of the model.

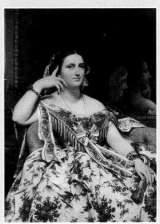

Ingres (1780–1867), Madame Moiessier. National Gallery, London. Ingres reintroduced pictorial classicism. His style is full of detail and suggestiveness.

Goya

Goya holds a somewhat isolated place within the evolution of European art. He is the only Spanish artist of his time who is comparable to the artists of the rest of the continent, and it is difficult to place him within a continuous pictorial tradition. However, his attitude towards the portrait is decidedly romantic. His portraits are so personal that the viewer can easily see whether the artist hated or loved his models—if he scorned them or admired them. Goya shows reality through the filter of his feelings and tried to go beyond the presentation of an objective reality.

Ingres

A student of David, Jean-Auguste Dominique Ingres was a fervent defender of classicism. As a teacher he established the principals of the classical portrait, putting line above any other form of artistic consideration. For Ingres, all portraits began with a careful drawing that captured the likeness and all the details necessary for expressing the model's character. Only when the drawing was complete could the artist begin to add color.

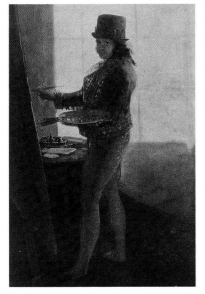

Goya (1746–1828), Self-portrait in the Workshop. Private collection, Madrid. Goya's independent attitude is reflected in portraits in which the artist shows his vision of character.

MORE ON THIS SUBJECT

- The Golden Age of the Portrait **p.12**
- Likeness **p.76**
- Characterization **p.78**

IMPRESSIONIST PORTRAITS

The traditions of Neoclassicism culminated in an official academic approach that dictated the style and contents of painting. The portrait had to ennoble the subject through clothing and specific accessories, as well as presenting only solemn poses that were suitable to each individual. The realist movement, to which Impressionism belonged, was a liberating reaction for painters who wanted more personal forms of expression.

Impressionism and the Portrait

The new technical contributions that Impressionism made (light represented by areas of color, color divided into touches of pure tone) tended to appear in landscape painting rather than portraiture. However, it is interesting to note that at this moment of schism with the academic styles of painting more portraits were painted than ever before. Not even photography managed to eclipse the painted portrait, despite the growing acceptance of the new medium for representing objective reality. The Impressionist portrait captured a feeling of light and color without worrying about the details of the scene or person. The Impressionist painter sought to capture the essence of the moment as experienced by the person being painted, allowing him- or herself to be guided by visual sensations without worrying about concepts or principles of artistic value.

The Problem of Likeness

For the Impressionists, a portrait is like a landscape or a still life: the person being portrayed is just another object, one of the many effects of light and color offered by reality. The attitude of the Impressionist painter is one of complete impartiality towards the subject, whatever it is. The consequence of this attitude was a debate about the traditional concept of likeness.

A likeness of the subject is the greatest justification that most members of the general public would find for a portrait. A representation that does not look like the person being painted, the general public would say, is not a good portrait. The Impressionists and most artists who followed them would argue that the important aspect of a portrait, as of any other pictorial genre, are its artistic qualities: composition, coloring, resolution of form, pictorial invention, and so on. This is the famous doctrine of art for art's sake according to which painting is justified by its forms and colors and not by its content. Arguments about this theory still continue to resonate, and it is impossible to come to a definitive judgement. What should be pointed out is that the Impressionists painted admirable portraits; no theoretical controversy can alter this fact.

Camille Pissarro (1830–1903), Self-portrait. *Musée d'Orsay, Paris. The Impressionist portrait is a fragment of reality shown with the full richness of light and color.*

Paul Cézanne (1839–1906), Portrait of Joaquim Gasquet. *Naroni Gallery, Prague. Cézanne's portraits are a conscientious study of the relationships between planes and chromatic values.*

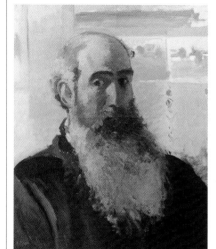

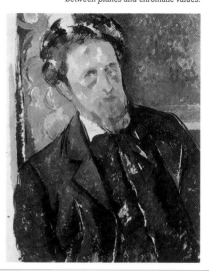

New Visions of the Portrait: The Romantic Portrait
Impressionist Portraits
The Expressionist Portrait and Caricature

17

Cézanne and Gaugin

Paul Cézanne is the forerunner of almost all the figurative painting of the twentieth century and by implication of the contemporary portrait. In his youth, he belonged to the circle of Impressionists who revolutionized French painting in the second half of the ninteenth century. However, Cézanne did not have the innate artistic ability of Renoir or Monet, and in the face of the evident unpopularity of his painting he shut himself away in his house in the south of France. There, he developed a style that went beyond the theoretical limits of Impressionism and moved forward towards the future. Cézanne's art is based on the rigorous pictorial reconstruction of the real world by means of the pure relationships of form and color. As a portraitist, he would often distort the physiognomy in order to achieve pictorial harmony. The most impressive aspect of his art is that, working from suppositions so far removed from realism, he achieved such energetic, convincing depictions of the human figure. Cézanne's pictorial

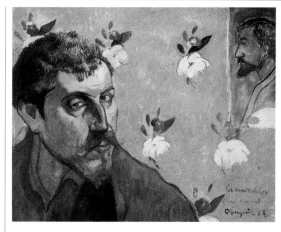

Paul Gaugin (1848–1903), Self-portrait. *Rijksmuseum, Amsterdam. Gaugin's decorative sense involved a daring view of color.*

distortion would be a source of permanent inspiration for generations of later artists.

Paul Gaugin was a little younger than Cézanne and learned from him that certain distortions of the figure can have more impact than pure realism. In his portraits and self-portraits he took any license necessary to achieve decorative effects that were highly attractive visually.

With Gaugin the portrait would approach the line that separates it from caricature, a tendency that would be followed by a multitude of painters.

MORE ON THIS SUBJECT

• New Visions of the Portrait **p.14**
• Expressive Color **p.70**

The Portrait as Snapshot

The appearance of photography had great repercussions on the art of the portrait. It was not so much a desire for emulation on the part of the painter, but rather the compositional and thematic possibilities that the instant nature of photographs opened up. In photography, the Impressionists saw perfectly natural, spontaneous scenes, small slices of daily life free from any academic rules of representation. Painters such as Degas were frequently inspired by photography to achieve new ways of framing a subject and new points of view for painting.

Edgar Degas (1834–1917), Madame Jeantaud Before a Mirror. Musée d'Orsay, Paris. A work inspired by a photographic snapshot. The frame and the composition, which seem to have been taken at random, were actually very carefully thought out.

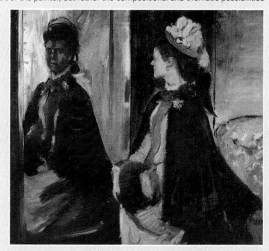

THE EXPRESSIONIST PORTRAIT AND CARICATURE

The artistic and social convulsions of the beginning of the twentieth century finally dissolved the distinctions between the genres, ended academic rules, and overturned the established principles of likeness and realism. The consequent artistic freedom manifests itself in expressionist styles that have dominated most of the century. These involve a very individual vision of the portrait.

The Expressionist Vision

Expressionism aimed to shake the viewer's emotions by means of surprising pictorial effects. These could be chromatic (violent contrasts or unexpected harmonies), formal (distorted or simply fantastic forms), or linked to facial expression (features that are either exaggerated or simplified to extremes). The painter tried to express his or her imagination with as much energy as possible, making use of all the media available, however subjective or irrational the results might appear. Applied to portraiture, this artistic method produced some unusual results. Using means that were far removed from conventional realism, painters discovered ways of achieving psychological characterization that was richer and deeper than mere naturalistic description of gesture or features. In the century of psychoanalysis, the portrait became an investigative tool for revealing the darkest areas of the human soul.

The "Destruction" of the Portrait

Many artists in the twentieth century have tried to take the innovations of their predecessors one step further, moving in two basic directions: either the portrait should no longer be based on a good likeness, or it should be destroyed as a genre. The first option implies placing all the importance on personal expression, producing images of reality that are distorted to greater or lesser extent; the second implies eliminating from painting any thematic material, making art itself the theme of painting. Many of the cubist portraits, as well as some by Matisse or Modigliani, are more concerned with the relationship between shapes and colors, between planes, light and shade, arabesques, lines and

Van Gogh (1853–1890), Portrait of Doctor Gachet. Private collection. Van Gogh tried to arrive at a psychological likeness by means of distortions and the intensity of color. He was the pioneer of the expressionist vision of the portrait.

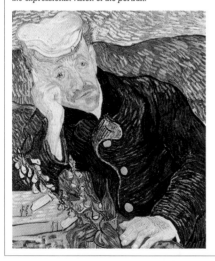

Toulouse-Lautrec (1864–1901), Jean Avril Dancing. Musée d'Orsay. The emphasis on expression and movement took Lautrec to the threshold of caricature.

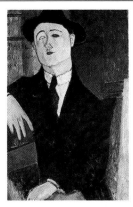

*Amedeo Modigliani (1884–1920),
Portrait of Paul Guillaume. Gallery
of Modern Art, Milan. A graphic
synthesis of facial characteristics
that succeeded in emphasizing
the feeling of likeness through
unconventional means.*

surfaces than they are about real
figures. They are artistic con-
structions that are born from the
internal vision of the artist.

Gustav Klimt (1862–1918), The
Three Ages of Woman *(detail).
National Gallery of Modern Art,
Rome. Expressionism shows a
special interest in the possibilities
of pure color and in the distortion
of form when applied to the
portrait and the human figure.*

The Caricature

The classical painter Ingres
knew that in order to capture the
personal expression of an
individual it was more effective to
exaggerate certain significant
aspects than to imitate the
features of the face. He knew
how useful caricature was as
a tool for achieving a good
likeness. Some of the painters of
the twentieth century developed
this tool to its limit, creating their
portraits by means of abbreviated
signs instead of precise represen-
tations. These signs demonstrate
a suggestive power that is as
significant, or more so, than the
combination of light and shade
with which figures are represented

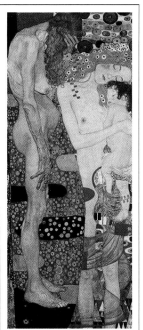

using more conventional styles.
The artist purifies and simplifies
his or her methods in order to
give them a more direct expres-
siveness, and draws figures using
simple, clearly arranged shapes.

Expressive Distortion

The distortions that are
customary in the portraits of
modern painters should not be
interpreted as unjustified whims of
the artist, but rather as expressive
exaggerations that convey a more
effective representation of the
personality or pose of the subject.
Exaggerating the curve of the
forehead, reducing or increasing
the features, or disrupting the
symmetry of the face were
methods that some classical
painters such as El Greco had
used with great skill. In
contemporary painting, this
type of artistic license aims to
achieve a more precise and vivid
presence.

Modern Symbolism

At the beginning of the
twentieth century the sym-
bolist tendency recovered
aspects of portraiture that
had been forgotten during
the Renaissance. Symbol-
ism goes beyond reality by
seeking signs that evoke
complex meanings. Gustav
Klimt is the most famous
portrait painter to use this
style. His portraits include
evocations of the subjects'
talents, together with
symbols of love, passion,
and elegance within
surroundings that are
almost dreamlike, charged
with sensuality and
decorative sensibility

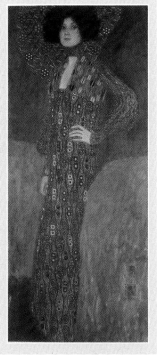

*Gustav Klimt (1862–1918),
Portrait of Emilie Floge.
Historisches Museum,
Vienna. Klimt used a great
deal of artistic license
in his painting to
express symbolically
the temperament
of his subjects.*

MORE ON THIS SUBJECT

· Caricature **p.80**

PROPORTIONS OF THE HEAD

It is well known that since antiquity art has been particularly preoccupied with the dimensions and proportions of the human body and all its elements. Of these, the head and the face have been and still are worthy of most attention, as it is here that the personality and spirit of an individual are seen. However, to reveal character, every artist must take into account the dimensions of the head and the features of the face.

Canon of the Male Head

In order to draw heads, faces, and portraits correctly, it is vital to study the dimensions and proportions of the human head. This is defined by a *canon,* a rule or norm that determines the measurements of the human figure based on a standard unit called a *module.* The most well-known canon is the one that the classical Greek sculptor Polyclitus established for the human figure: His famous sculpture, called *Doryphorus* (the spear bearer), was a figure whose height was seven and a half times the size of its head. This proportion was considered to be the norm to follow for artists. The influence of this canon, via multiple variations and stylizing, still exists today. Polyclitus' sculpture not only established a norm for a figure's height, but also for the proportions of the limbs. Similarly, a canon can be established for the parts of the human head and applied to all types of drawings of human faces—either from a point of view of aesthetic idealization (to create a representative type of artistic or natural beauty) or for the representation of specific characteristics of a particular person. Thus, these proportions are a fundamental reference for creating the linear structure both of a portrait and of an imagined face.

Front View of the Head

According to the canon, the male human head is three and a half times the size of the height of the forehead. The forehead is taken as the basic measurement or module from which the proportions of the other parts of the face are determined. The height of the head is divided into three and a half units by means of five horizontal lines: these mark the top of the skull, or the upper limit of the head; the area above the forehead, which usually coincides with where the hair starts; the level of the eyebrows,

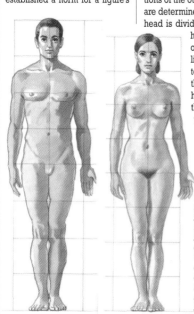

This is the canon used in modern figure drawing: the male and female figures measure eight head-lengths. The smaller stature of the female figure does not affect this proportion, as the size of the head is smaller.

which is the same level as the top of the ears; the base of the nose; and finally the base of the jaw, or the lower limit of the head. If the same measurement (the height of the forehead) is applied to the width of the head, the canon dictates two and a half units.

Thus, the following rule can be established: The height and width of the human head seen from the front is like a rectangle that measures two and a half units wide by three and a half units high.

If the rectangle is divided vertically and horizontally with two lines, the horizontal line defines the position of the eyes, and the vertical one, the central axis of the nose.

Finally, it is also important to note that the distance between the eyes is the same as the width of one eye, and that the lower edge of the lip coincides with a line that divides the lower module into two equal halves.

Profile of the Head

The canon established for the head seen from the front also applies to the head seen in profile. It is only necessary to extend the horizontal lines and draw all the details of the face, this time in profile: the upper edge of the skull, the top edge of the forehead, the level of the eyebrows and ears, the lower edge of the nose, and the base of the chin.

Taking the same module that was used for the front view of the face (the height of the forehead), the width of the head in profile is also established as three and a half times this measurement.

If the rectangle is divided vertically into three equal parts, the segment that goes from the

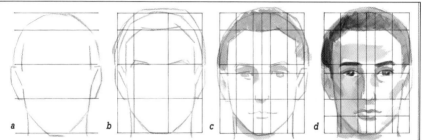

a) The height of the male head, seen from the front, is three and a half times the height of the forehead.
b) The height and width of the male head seen from the front can fit in a rectangle that measures two and a half units wide by three and a half units high.
c) From these modules the positions of the eyes, nose, mouth, and ears can be established by dividing the rectangle into two halves, drawing a half module on the vertical line, and adding a quarter module to the central horizontal axis.
d) With these divisions it is possible to construct all the features of the face.

tip of the nose to the outside tip of the eyebrow gives the points of reference for constructing the profile, fixing the position of the eye, the eyebrow, the mouth, the nose, and the hairline. The width of the central segment establishes the distance between the end of the eyebrow and the beginning of the ear.

Symmetry of the Face

The symmetry of the face seen from the front makes it possible to calculate in advance the relative positions of the features, knowing that they are distributed in the same way from left to right.

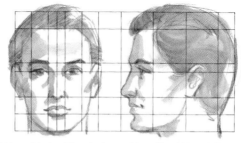

Divisions of the head from the front and in profile, which mark the respective positions of the features.

The face seen from the front always has a basic axis positioned in the center, which defines the position of the nose in the oval of the face. Although perfect symmetry is only an abstract concept, on most faces one side is almost a mirror image of the other.

The Canons

In ancient Greece at least three canons were defined, all of which took the height of the head as the module or unit measurement for the height of the human body. The best-known canon is that of seven and a half head-lengths, but a canon of eight and a half head-lengths, which appeared during the Hellenistic period, is also widely accepted by artists. During the Renaissance, artists continued to try and find the "true" canon. Dürer was one of the keenest researchers into human proportions, believing that therein lay the secret of artistic beauty.

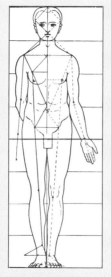

A proportional canon of eight head-lengths, with additional indications for the proportions of the human body, designed by the painter Albrecht Dürer.

MORE ON THIS SUBJECT

• Anatomy of the Head **p. 28**

Proportions and position of the facial characteristics of a head in profile.

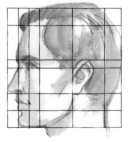

THE FEMALE FACE

The female face is possibly the subject that portraitists have treated most frequently. Artists of all periods have studied and painted the female face with particular dedication, perhaps because they believed that it best represented the concept of beauty in the sphere of art. Because of this it is possible to see how the ideals of beauty and artistic harmony have evolved through time.

Characteristics

Differences between the dimensions of male and female faces are minimal. The physical differences of the female face are principally due to the structure of the bones, the presence of a greater amount of adipose tissue, and a different skin quality.

Generally, the female face is a little smaller than the male face. For this reason, given that women's eyes are the same size as men's eyes, they always appear larger; the eyebrows are higher, more arched, and generally finer; the nose and mouth are also smaller; and, similarly, the jaw is more rounded.

All these differences can be emphasized by the cosmetics a woman might use to highlight her face, eyes, lips, cheeks, and by hairstyle. It is clear that a woman's makeup, with its bright colors, can be a very important factor in artistic portraits.

From the Front

The canon of the female head is the same as that of the male. The face seen from the front is similarly composed of three and a half modules in height—bearing in mind that the measurement for a module is the height of the forehead—by two and a half modules in width. This structure therefore gives the same rectangular frame as in the male face. However it is important to notice the physical differences of the female face. In the first place, a woman's chin is not as square as a man's. It is a little narrower, like an oval that goes from one ear to the other, for which reason the female face seems rounder than the male's. In the second place,

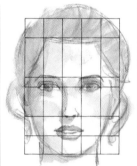

Proportional divisions of the female head. These subdivisions are slightly different than those of the male face.

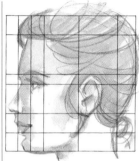

Proportional divisions of the female head seen in profile. These subdivisions are extensions of the previous ones.

both the mouth and the nose are a little smaller. The mouth is narrower, although the lips are thicker. The nose has softer lines. The eyes, in contrast, seem bigger; this impression is increased by the height of the eyebrows, which are not as thick as the man's. Finally women usually have more hair, and the top of the hair is almost always higher than in a man. This detail helps to give the woman's head a more oval shape.

In Profile

As has been said, the canon for the female head is the same as for the male head, for which reason the female profile is also three and a half modules wide, although it is

necessary to take into account certain small physiognomic differences. The profile of the chin is less pronounced than on a man; on the other hand, a woman's lips stick out more than a man's; the jaw is rounder and less pronounced. The nose is shorter and more turned-up, and it does not stand out as much as in the male profile. The area of the eye seems a little bigger due to the position of the eyebrow. The forehead follows the line of the face more softly, because the female skull is not as pronounced

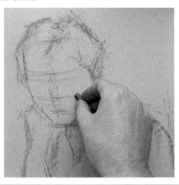

The female portrait begins with the ordering of the proportional divisions of the facial features.

Once the basic proportional divisions have been found, it is easy to establish the exact shape of the features.

MORE ON THIS SUBJECT

- Anatomy of the Head **p.28**
- Basic Structure of the Head **p.30**
- Characterization **p.78**

more so, in the creation of the drawing than the correct definition of the skull and the face. It is necessary to study this volume carefully, understanding the downward movement of the locks of hair and the way it waves. However, it is also important to imagine the shape of the skull hidden by the hair, and to understand the hair as a covering that adapts itself to the curvature of the skull.

as the male skull. Finally, the smaller size of the ear gives the impression that it is set further apart from the other facial features than the man's ear.

The Hair

A woman's hairstyle is an element that must be taken into account in the study of the proportions of the female head. Voluminous hairstyles, as well as long hair, change the appearance of the face either by emphasizing its oval shape, enlarging it, or lengthening it. Sometimes the volume of the hair is considerably greater than that of the head.

Accurately representing the hair volume is as decisive, or

Frans Hals (1580–1666), Gypsy Girl. The Louvre, Paris. The hair is a decisive factor in female physiognomy; it highlights the oval of the face and emphasizes its outlines.

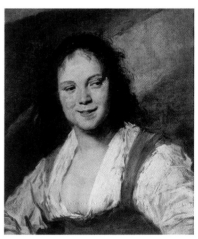

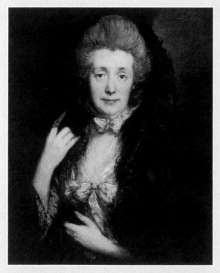

Characterizations

The female portrait can offer more opportunities for characterization than the male portrait. Apart from the question of physiognomy, the headwear, details of clothing, the hairstyle, and so on are important elements of character. This fact has been exploited by all artists, especially in periods when women's clothing included a rich array of accessories that could be combined in the portrait according to criteria of form, color, and composition.

Thomas Gainsborough (1727–1788), Portrait of the Artist's Wife. Courtauld Institute, London. The headwear and accessories have been used by all portrait painters to emphasize the beauty of the women being painted.

THE CHILD'S FACE

The characteristics of a child's face are not the same as that of an adult, and so it is necessary to measure and study its proportions. Artists know that a child's portrait can be extremely difficult to paint. In addition to their special physical characteristics, children are usually unable to hold a pose for any length of time.

Characteristics

At first sight it is obvious that a child's head is smaller than an adult's, but it is necessary to stop to consider what actual factors differentiate it. The characteristics of a child's head can be defined in comparison to an adult's head. In the first place, it will be noticed that although the child's head is approximately half the size of an adult's, it is much larger in comparison with the body. In the second place, the size of the skull always stands out, being disproportionate to the dimensions of the facial features. As far as these are concerned, it is the eyes that most draw one's attention: the eyes of a child are always proportionally bigger than those of an adult. In contrast, a child's nose is smaller and more turned-up, as the nasal bones are still rather undeveloped. The jaw has not fully grown either, and the lower jawbone is very small in comparison with an adult's chin. As a final general characteristic, one must mention the sides of the face, which always appear to be inflated and bulging, giving a general impression of roundness to the face.

Front View

It has already been observed that the proportions of an adult's head seen from the front can be fitted into a rectangle measuring two and a half units wide to three and a half high, taking as the unit or module the height of the forehead. These proportions do not apply to a child's head. The child's face can be fitted into a rectangle that measures three units wide by four units high. The

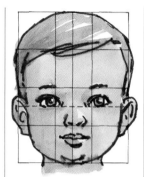

Proportions of the child's head seen from the front. The proportions differ significantly from those of an adult.

basic module is the height between the bottom of the chin and the base of the nose. The second module is from the base of the nose to the eyebrows. The third module is the distance from the eyebrows to the top of the forehead. And the upper module is the one that corresponds to the skull, which, as already mentioned, is proportionally bigger than that of an adult. The line that acts as the base of the eyes can be found by dividing in half the module in which they are located.

View in Profile

By applying the same module as before, the head of the child seen in profile is marked by a box that is perfectly square. Beginning with the nose, the first module goes from the tip of the nose to the

edge of the eye. The second goes from the eye to the front of the ear. The third stretches from the front of the ear to a point just behind the ear. The last module corresponds to the back of the skull.

The small size of a child's face is evident (the facial bones are still not fully developed) when compared to the large size of the skull, which almost always makes children look big-headed.

The artist must bear in mind these anatomical characteristics not only when drawing children, but also in any drawing in which they appear. A very common error is to apply the characteristics of an adult's face to a child's, changing only the size. The result is "children" that resemble miniature adults.

Familiarizing yourself with the proportions of a child's head is not at all difficult. Once you have done so, it is very simple to draw children, either from life or from memory, with the same ease with which you draw the basic lines of an adult's head. Facility is especially important when drawing from life. Because children rarely are willing to remain still, you will have to train yourself to work very quickly.

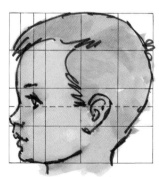

Proportions of the child's head seen from the side. The divisions are modified by the fact that the skull is proportionally larger.

Proportions and Phases of Growth

A child's growth naturally alters the relationships of proportions of the head and the facial features. The measurements considered up to now correspond to a child between two and four years old.

By the time a child reaches the age of five or six, the forehead is not so prominent and its upper part is partially covered by hair. The development of the jaw makes the face look longer and the features occupy a higher position within the face.

By the age of twelve, the child's chin gradually starts to lose its curved shape and the features are even more centered within the skull.

Between the ages of twelve and fifteen or so, the development of adolescence brings the adult facial proportions studied previously.

Facial Symmetry

When considering the symmetry of the child's face and comparing the distribution of the features, it will be noticed that the eyes are generally much wider apart than those of an adult, for which reason the rule that the space between the eyes is equivalent to the width of one eye does not apply.

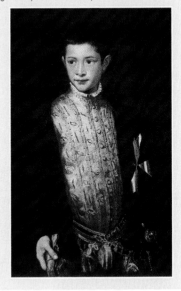

Titian (1487–1576), Ranuccio Farnese (detail). National Gallery of Art, Washington. The separation of the eyes is one of the decisive factors in achieving an authentic child's expression.

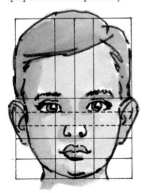

Proportions of the head of a child of six years: the head has grown, the jaw is more developed, the eyes and eyebrows are higher.

MORE ON THIS SUBJECT

· Anatomy of the Head **p.28**
· Basic Structure of the Head **p.30**
· Pose **p.50**

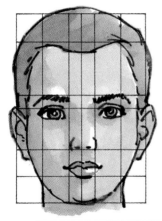

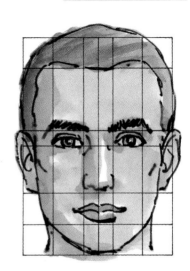

Proportions of the head of a nine-year-old child: the eyes and eyebrows have still not reached the mid-point of the head vertically, but the outline of the lower jawbone is beginning to stand out.

Proportions of an adult head.

THE FACE IN OLD AGE

If the female face offers painters the chance to express beauty in its most obvious manifestation, age is an ideal subject for an artist to give a subject a moral or psychological meaning. Character, temperament, and human expression as the product of experience accumulated with the passing of time, complete with all the unavoidable personal vicissitudes of life, all mark the face of a person of advanced years. These faces are ideal subjects for demonstrating artistic qualities and for showing the capacity of the painter for capturing psychology.

Male and Female in Old Age

It must be remembered that men and women do not age in the same way. In childhood it is difficult to differentiate between a girl's and a boy's face, because male and female characteristics have not yet had time to develop fully; in old age these differences are accentuated both physically and psychologically. It is said that physically women show signs of aging more than men. This is an observation to be taken into consideration. The attributes of gentleness, elegance, and delicateness do not resist the passing of time as well as the harder, more marked physical characteristics of the male face. In contrast to what happens with women, these characteristics etch them-

The most significant features of the face in old age must be represented clearly in the initial stages of the portrait.

selves more clearly on the face, for which reason artists often prefer to portray old men rather than old women.

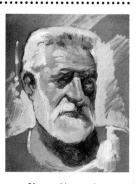

After marking out the correct volumes of the face, lines and wrinkles can be introduced.

Significant Characteristics

There are certain facial features that unequivocally indicate the advance of age. In the first place, the loss of hair, which in men is much more evident than in women, and which radically affects the appearance of the face. A sinking of the temples is very common, at the same time emphasizing the crest of the temporal bones on the sides of the face. The bony crests of the eyebrows also stand out due to a sinking of the eyes, under which bags and wrinkles form, making them look smaller. As the skin loses its smoothness and the tissue shrinks, the cheeks fall and accentuate the prominence of the cheekbones. The lips grow thinner. Finally, as a general, more obvious factor, wrinkles appear, the skin becomes flaccid in certain areas, and bags develop, especially on the cheeks and neck.

The female face in old age does not show the outline of the bones of the skull as much as in the male.

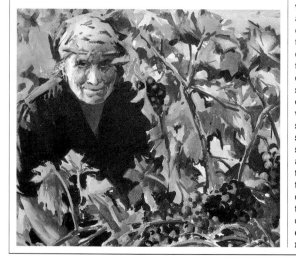

Volumes

Because of these changes, it must be remembered that the volumetric values of an old person's face are not the same as those of someone younger. The facial volumes that make up a young face depend, above all, on muscles, tissues, and the texture and firmness of the skin. In contrast, the face of an elderly person has lost a lot of these qualities and will as a result be much more marked by the volume of the bones. The face of an elderly person shows especially the bones of the cheeks, jaw, nose, and skull, clearly revealing the configuration of the facial bones and unmistakably showing their more massive appearance.

Lines and Wrinkles

As has been noted, the most obvious aspect of the face of an elderly person is its lines. In the case of men, as the quality of their skin is harder than that of women, deeper, more marked lines, called wrinkles, can be found. Both lines and wrinkles, as with all irregularities, offer the artist a wealth of artistic possibilities. These irregularities can also help the painter, because they act as points of reference to make it easier to calculate dimensions, distances, and proportions. Lines and wrinkles

Old Age and the Color of the Skin

A common error among certain portrait painters is to use the same tones for all types of portraits. The flesh in old age is less uniform than in other age groups. It is necessary to study these tones and represent them clearly to avoid creating effects that are false or too conventional.

In this work by Vinenç Ballestar, the flesh has a peculiar toasted appearance, which emphasizes the lines and wrinkles of old age.

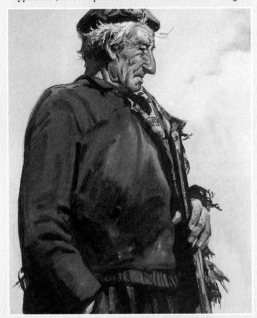

appear most frequently on the forehead, around the eyes, on the cheeks, and around the neck.

MORE ON THIS SUBJECT

- Basic Structure of the Head **p.30**
- Flesh Tones **p.68**

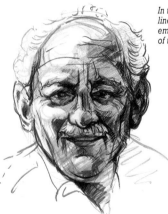

In this man's face the lines and wrinkles emphasize the volume of the skull.

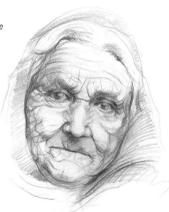

The areas and wrinkles of the female face are distributed on a volume that has more adipose tissue than the male face.

ANATOMY OF THE HEAD

To produce a good portrait it is not necessary to have a deep knowledge of anatomy, but it is useful to be able to recognize and remember the structure of the most important bones and muscles. It is not by chance that anatomy provides the base or "hidden face," which determines the outward appearance of the visible face. Who has not at some time seen a skull? All that is necessary is to pay a little more attention to its details.

Bones of the Skull

The main bones of the skull are the following: frontal, occipital, parietal, temporal, zygomatic, nasal, upper maxillary, lower maxillary.

One of the most important structural elements is the temporal bone. The extension of this bone, in the form of a crest from the cheekbone backwards, forms the zygomatic arch. If one looks at the skull from the front, one can see the zygomatic arch standing out from the corresponding

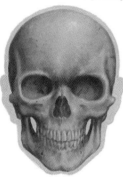

The bones of the skull seen from the front. Many of the bones show their volume prominently in the configuration of the face.

The bones of the skull seen from the side. In the drawing of a portrait in profile, the volume of the bones is less visible than in the front view.

plane of the temporal bone. In some faces, especially in the thin and the old, this gentle sinking of the temporal bone creates a considerable difference in level between the plane of the ear and the plane of the end of the jawbone.

The nasal bones, despite being small, establish the appearance of the nose, making it straight, flat, hooked, and so on.

The Lower Maxillary Bone or Mandible

Observation of the human head reveals two basic parts: the skull and the lower maxillary bone (composed of the mandible and chin). The latter is the only part of the head that has movement; it moves when we laugh, cry, speak, and eat. For this reason it is vital in giving the face expressions of all type, especially extreme expressions like laughter or panic. Its articulation is very simple: where the mandible joins the zygomatic arch there is a small bone or condyle situated transversally, which acts as an axis and hinge, allowing the upward and downward movement of the mandible.

The mandible or jawbone is the only articulated joint in the skull. As the only movable bone in the head, it is involved in the most obviously visible facial expressions.

Muscles

The muscles of the human head are divided into two groups: 1) the expressive muscles, which include the frontal, orbicular of the eyes, orbicular of the lips, buccinator, triangular muscle of the lips, depressor of the bottom lip, larger and smaller zygomatics, and the risorial; 2) the muscles

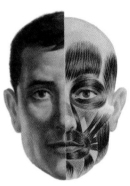

Muscles of the head seen from the front. This group of muscles, which are responsible for most facial expressions, include the frontal, orbicular of the eyes, orbicular of the lips, buccinator, triangular of the lips, zygomatic, and risorial.

Side view of the muscles of the head. These two muscles are associated with chewing.

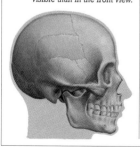

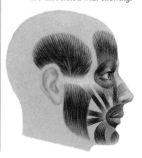

The Face in Old Age
Anatomy of the Head
Basic Structure of the Head

29

for chewing, which include the temporal and masseter.

The expressive muscles permit facial movements and all human expressions. Some of them are found inserted into the skin, or interlaced with other muscles without being joined to a bone.

The chewing muscles are directly related to the movement of the mandible.

Volumes

It can be said that the fundamental volume of the human head comes from the skull and its structure, to which are added the forms of the muscles in all their combinations. Finally, there is a layer of fatty tissue that varies in thickness.

The head seen from the front gives a general impression of oval volume, framed at the top by the rounded, ball-like cranium

The Skull and the Portrait

The volume of the skull affects the physical appearance of the subject's head. However, the artist does not need an exhaustive knowledge of the bones and muscles of the skull to create a good portrait. It is sufficient to have a general understanding of anatomy. Careful observation will make clear which are the most significant protuberances of the head and to which anatomical elements they correspond.

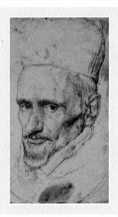

Velázquez (1599–1660), Cardinal Borja. The Prado, Madrid. *In this magnificent sketch by Velázquez, the bone structure is clearly visible beneath the subject's skin.*

and at the bottom by the curve—more angled in men—of the jawbone. The roundness of the cheeks and cheekbones which fill in the face in a (relatively) uniform way complete the spherical volume. Three appendices stand out to break this general uniformity: the ears and the nose.

MORE ON THIS SUBJECT

• Proportions of the Head **p.20**
• Basic Structure of the Head **p.30**

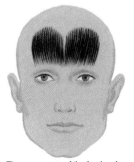

The movements of the forehead are due to the frontal muscle. They are linked to the raising of the eyebrows.

The orbicular muscles, which surround the orbits of the eyes, move the eyelids.

The buccinators permit the contraction and dilation of the cheeks.

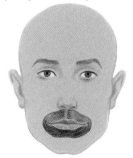

The orbicular muscle of the lips allows for their movements of pursing and contracting.

The triangular muscle of the lips allows them to be tensed at the ends, by drawing them downwards.

Apart from the function that the name itself suggests, the elevator of the upper lip dilates the nostrils and is involved in the formation of the lines below the cheeks.

THE STUDY OF THE FACE

BASIC STRUCTURE OF THE HEAD

Drawing the head successfully requires an understanding of its anatomy and its proportions. Once you have acquired a clear idea of the basic structure of the head, you will be able to avoid errors in drawing and painting portraits. The structure, or framework, which is based on simple, practical, geometrical outlines, is captured in brief sketches that show the form and from which the features can be defined.

• •

General Framework

In previous chapters the shape of the skull and the way it underlies the features of the face have been explained. When drawing the human head, the structure of bones provides the basic framework for the general outline. In the beginning it is a good idea to sketch these lines on the drawing of the skull. The head seen in profile can be reduced to the form of a sphere. To this sphere the outline of the jawbone is added. This is the most simple sketch of the head. Draw a slightly angled line to show the plane of the face. With this line you can calculate the divisions that correspond to the three and a half modules, and use the divisions to situate the mouth, nose, and eyes. It is even easier to draw the outline of the head from the front. The basic form of the sphere is flattened at the sides, and the rest of the outline is formed starting from the triangular line of the lower jawbone. In order to place the elements of the face, it is merely necessary to draw its symmetrical center (in the middle of the face) and to make the divisions of the three and a half modules.

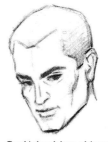
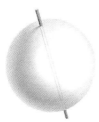

Graphic breakdown of the process of creating a sketch of the head. As a first step, it is necessary to see the head as a sphere whose axis is marked by the angle of the neck.

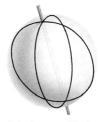
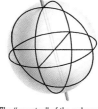

The first references of the sketch correspond to two circles situated vertically and horizontally in relation to the axis. These circles are the central divisions of the face seen from the front and in profile.

The "equator" of the sphere is the central division of the head.

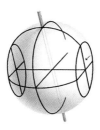

Finally the sphere is flattened at the sides to make it fit the flat surface of the sides of the head. A precise sketch of the framework like this one allows us to understand the geometrical concepts involved in structuring the head.

Partial Framework

For partial outlines in the view from the front, it is necessary to bear in mind the divisions and proportions of the canon and the symmetrical center of the face. Once you have drawn the general line of the skull and jawbone, you can draw the line of the mouth, which coincides with the circle around the skull. Above the mouth, in the second module, mark the line of the nose, which

The geometrical sketch of the framework follows the general form of the skull: a sphere that is flattened at the sides.

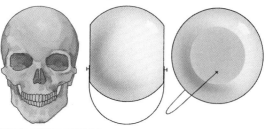

Anatomy of the Head
Basic Structure of the Head
Eyes and Eyebrows

31

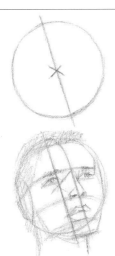
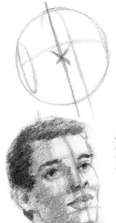
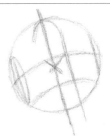

From the framework of the sphere it is possible to construct with ease a head that is correctly proportioned in any position.

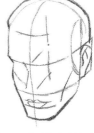

Framework of the facial features made by adding detail to the basic geometrical sketch.

MORE ON THIS SUBJECT

· Proportions of the Head **p.20**

coincides vertically with the symmetrical center of the face. The line of the module that marks the base of the forehead also marks the upper edge of the eyes and the eyebrows. The line of the eyes is horizontal, that of the nose vertical, so the two axes form a cross. Most artists begin drawing the outlines of their portraits with this cross, which they use to position the eyes, nose, and mouth.

Proportions

For a correct layout of the parts of the head it is vital to find the correct proportions between the circle of the skull and the projection of the jawbone. It is necessary to consider that the mouth, the nose, and the eyes are all located a similar distance from one another. They make a perfect inverted equilateral triangle whose upper vertices coincide with the outer corners of the eyes, and whose lower vertex coincides with the base of the lower lip.

As far as the profile is concerned, one must remember that the line of the eyes is the principal center of reference, above which are found the eyebrows, the forehead, and the top of the skull; and below which lie the nose, the mouth, and the jawbone. The length of the nose is equal to the length of the chin,

lips, and the space between the mouth and the nose.

Framework of Movement

It is relatively easy to draw the framework of a head seen from the front or the side. What is not so easy is to create the framework of a head that appears to be moving up and down or to the side. For this it is necessary to practice drawing a circle in perspective. Start with a circle within a square, which in turn is within a cube. In this way it is possible to draw circles that are equidistant and seen in perspective, related to the volume of a sphere. If one draws a cube

in different perspectives, it is possible to modify with perfect accuracy the view of the circle and of the points of reference for the framework of the head in movement.

Frameworks and Composition

In all portraits, the framework of the head must be incorporated into the general composition of the work. In most portraits, the head is not seen exactly from the front, but slightly turned, either in profile or from a different angle. The distribution of the features must follow the system of distribution described previously, but for the overall framework of the head one must also take into account the measurements and proportions of all parts of the subject's body that are visible.

Francesc Domingo, Child's Head. Private collection. This simple drawing owes its attraction to the precision of the features and the tight composition.

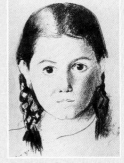

EYES AND EYEBROWS

It is said that the eyes are the mirror of the soul. It's true. In any portrait, if the eyes are hidden the face immediately loses its interest, its life, its soul. The sensation of reality that a portrait can provide is especially linked to the eyes and eyebrows, which also play a fundamental role in the expression of mood and psychological reaction.

Position

The eyes and eyebrows are placed one on either side of the nose, an obvious statement that is useful to bear in mind for taking the axis of the nose as the reference point for the drawing. The axis of the eyes crosses this vertical axis at right angles. It has already been said that the eyes are located in the exact center of the head (at the mid-point in height) and that the distance between one eye and another is the same as the width of one eye. The eyebrows form a curved arch above each upper eyelid. The line of this arch tends to sink a little towards the nose and to rise lightly as it approaches the temples. In profile, the plane of the eye is behind the plane of the forehead and the eyebrows. Seen from the front, if the head is tilted downward, the concave space in which the eyes are found makes them appear in back of the eyebrows, and almost hidden by them. If the head is lifted, the eyes are visible below the eyebrows.

Form

Once the position of the eyes and eyebrows has been determined, it is easy to sketch their form. Remembering that the eyes are located in a circular hollow (the orbital cavity), two symmetrical ovals can be drawn, one on either side of the face. Within these ovals the eyes and the eyelids can be drawn with more detail; just above the ovals position the eyebrows, to make a single, unified form.

Volume

The most important and fundamental point to remember is that the eyes are spherical. The shape of the eyelids is what gives the eyes their oval-shaped

The form of the eye can be looked on as a sphere with limited possibilities for movement. On the outer face of this sphere are located the iris and the pupil.

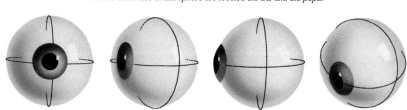

Taking this initial sphere, the form and position of the opening of the eyelid can be seen.

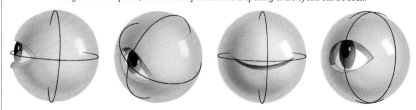

Once the position and form of the eyelids are decided upon, it is easy to draw the real form of the eyes from different view points.

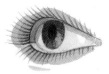

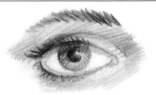
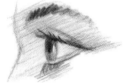
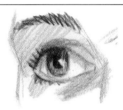

Three different views of an eye: from the front, in profile, and a foreshortening.

appearance. Similarly, whether the opening of the eyelids is wider or narrower will determine whether the eyes appear larger or smaller. The eyelids are found on the forehead, which is a curved surface, and more so at the edges than in the center. The clarity of the look also depends on the eyebrows. They can be very bushy, to the extent that they almost cover the eye; they can be fine and even, especially in women; they can be arched, or almost straight; they can be uneven both in line and volume; and so on. To represent the eyebrows, it is necessary to vary the intensity of your brush or pencil strokes so that they imitate the greater or lesser amount of hair and the different volumes and tones that some parts have in comparison to others.

The Glance

Draw a sphere with a small circle on its surface and look at it from different points of view. You will encounter almost the same problems when drawing the particular glance of your subject's eyes: foreshortenings and perspective, representing the look from one side or another, from straight ahead, and so on. If you remember that the eyes are like this sphere, with both eyes moving at the same time, and that they are basically two identical bodies seen from a different angle—depending on the movement—it will be easier to draw the movements of the look.

Ingres' Advice

Ingres advised his students to draw the eyes "in passing," that is to say, without paying them too much attention, capturing their shape quickly, and painting or drawing them rapidly and simply. Structurally the eyes are an almost insignificant detail within the facial features. Their psychological importance, however, is enormous. The artist should avoid weighing the picture down or distorting it by emphasizing the eyes too heavily or thinking about them too much while producing the rest of the picture. If necessary, the eyes can always be retouched later.

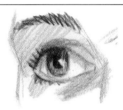

Ingres (1780–1867), Portrait of Paganini. *The Louvre, Paris. The vividness of the look in Ingres' portraits is based on the "casual" capturing of the eyes' form and movement.*

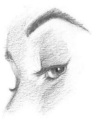

In this side view one of the eyes is almost completely hidden by the nose.

The eyes are always on the same axis. In this drawing they are seen from below.

MORE ON THIS SUBJECT

· Basic Structure of the Head **p.30**

When the eyelids are closed, the spherical form of the eyes is apparent.

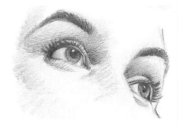

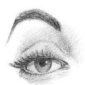
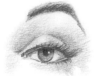

The eyes are two identical bodies that are completely coordinated when they move. This drawing shows a front view of the eyes and their location with respect to the eyebrows.

THE NOSE AND EARS

The nose and the ears are appendices of the head. They are the parts of the face that extend beyond the oval formed by the shape of the skull. It is useful to pay close attention to them and observe them carefully because their shapes are not easy to capture. Moreover, they are essential (especially the nose) in achieving a good likeness. However, the huge variety of shapes does not mean one cannot make a few general observations about drawing these parts of the body.

Position

Seen from the front, the nose is located in the center of the face. It coincides with the vertical axis that divides the face into two equal parts. The top of the nose marks the beginning of the forehead and eyebrows. On the same level as the bottom of the nose is found the earlobe and the top part of the jaw. The ears are never longer than the distance between the eyebrows and the base of the nose. In profile, and depending on the configuration of the bones, the nose can be either prominent or discrete, concave, convex, or straight. Whatever it is like, the measurements and proportions studied up to now will act as a reference. The ears, which follow a line marked by the jawbone, are found behind the extension of this line.

Form

First of all, it must be taken into account that both the ears and the nose are found in the central module of the head. Knowing that the nose lies in the middle of the face when seen from the front, it is not too difficult to delineate the wings of the nose and the nostrils. The ears, which are a little more difficult to sketch, are the part most outside the framework of the face. Nevertheless, they should never extend above the line of the eyebrows, and the lobe of the ear should not go below the level of an imaginary line drawn at the height of the upper lip. The geometric figure that corresponds to the form of the nose is a triangle, and that of the ears is an oval.

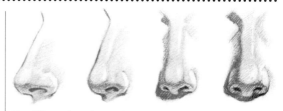
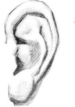
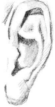

Four different views of a nose. Just as important as the correct form of a drawing in revealing the position and volume of the nose is the right distribution of light and shade.

The ears are much flatter than the nose, but their structure is rather more complex. The distribution of light and shade is also important when drawing the ear.

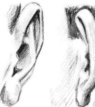

Volume

To capture the volume of the nose and ears the only solution is to observe each example carefully, to study it and understand its nature entirely. Perhaps the way to represent such an irregular volume is to ignore the fact that it is seen in three

Learning from the Masters

Studying from life is fundamental, but it is also possible to learn a lot about portraying significant facial details by looking at portraits painted by the great artists. Sometimes a work shows a solution that can be applied to one's own work because of its simplicity, or because it resolves problems posed by the work the artist is doing at a particular time.

Rembrandt (1606–1669), Portrait of Hendrickje Stoffels (detail). The Louvre, Paris. The volume of the nose is very rounded despite the discretion used in depicting light and shade.

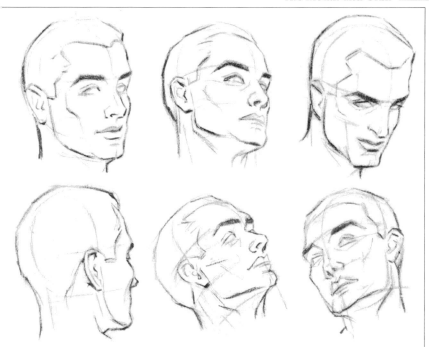

The nose and the ears, seen in relation to the rest of the facial features, can look very different depending on the position of the head.

dimensions. Instead, try to see the nose and ears as if they were flat objects, without relief. In this way you can eliminate the effect of foreshortening and capture the effect of light and dark that their irregularities create. Each subtle graduation of intensity, each tone, each highlight can be drawn and will create the sensation of volume corresponding to the reality that is observed. It is particularly important to bear this in mind when drawing the nose seen from the front; seen from the side, it is essentially a well-marked line. Similarly, careful observation is vital for shaping all of the small folds of the ears.

Relative Lengths and Sizes

No two noses or ears are the same. Everyone has their own type, or a detail that differentiates it from others. Noses can be small, large, hooked, turned-up, fat, thin, bony, fleshy, and so on, just as ears can

stick out, lie back, be round or long, to say nothing of the subtle differences in their internal folds. It is always necessary to observe the relative height of the nose with respect to the ears, because their heights do not always correspond to the central module of the face. There are some noses that, because of their length, reach the level of the mouth, or

MORE ON THIS SUBJECT

· Proportions of the Head **p.20**
· Basic Structure of the Head **p.30**

ears that extend beyond the line of the eyebrows or the lips. It is all a question of paying careful attention.

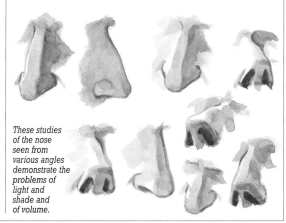

These studies of the nose seen from various angles demonstrate the problems of light and shade and of volume.

THE MOUTH AND CHIN

The mouth and chin appear to be easy elements to draw, but it is necessary to think about the countless number of movements of which the mouth and jaw are capable. These features combine a movable bone and a large number of small facial muscles that stretch, shorten, open, close, and so on. For this reason, before considering the question of expression it is necessary to observe carefully the position and movement of the mouth and chin.

Position

The mouth and chin occupy the lower part of the face, that is the lower module. Seen from the front, if this module is divided into two equal parts with a horizontal line, the upper half will contain the mouth and the lower half the chin. Both the mouth and the jawbone share the basic symmetry of the face, divided into two equal parts by its central axis. The chin is bordered by an oval line that stretches from ear to ear and which includes the entire area of the mouth. It is necessary to note that below the ears the face narrows towards the central point of the chin. With this in mind, the oval of the face can be drawn with a single line.

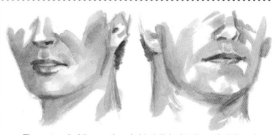

The portrayal of the mouth and chin is linked to the articulation of the neck. The framework of the head and neck is achieved through the development of light and shade created by their volume.

The Lips

The lips basically consist of profiles and shading. There is an infinite variety of lips: fleshy, narrow, terse, wrinkled, fallen, straight, and so on, but all these types can be drawn with a profile that delimits them and with graduations of shading that give them texture and volume. It is also necessary to consider that the lips are located on a curved plane, a factor that accentuates even further the feeling of curving lines and undulating surfaces. It is necessary to observe each gesture or expression of the lips carefully in order to understand that the smallest muscular movement can change their appearance, and thus their form of representation. It is very important to capture the corners of the mouth accurately—both their linear direction and their depth—because these govern each movement. Similarly, it is

Luis Meléndez (1716–1780), Self-portrait. The Prado, Madrid. An example of the pictorial treatment of lips. The upper lip is slightly more shaded than the lower one, and the line of the opening of the mouth stands out between them.

Here can be seen various examples of mouths drawn with pencil from different points of view. It is important to notice not only the outline of the mouth but also the shading of the lips.

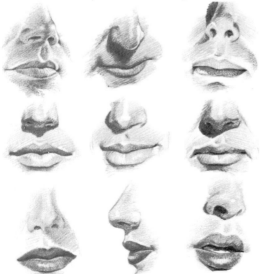

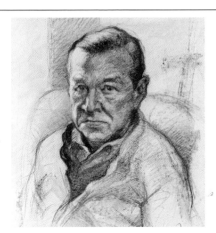

In this portrait of an elderly man, the mouth has been drawn in a simple way, and its essential elements appear with greater clarity.

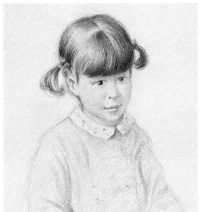

In children the line of the chin is smooth and continuous, without any notable interruptions other than the slight roundness of the cheeks.

clear that the lips of a man are thicker than the lips of a woman. In male lips the tones would be weaker; and in female lips, more intense and brilliant.

Chin and Neck

One of the great problems that artists have when drawing a figure is the correct structure of the head and trunk joined by the neck. The neck determines the movements of the head: from side to side or up and down. According to this position, the profile of the chin will be more or less marked and the neck will be mostly visible or mostly hidden. The width of the neck should not exceed the width of the jaw, but it can, in contrast, be a lot narrower than it, and not in line. Men's necks, which are usually wider than women's necks, have more muscular volume and appear rather shorter.

Movement

The movement of the mouth and chin is limitless. The lips are like springs that can stretch and contract to give thousands of subtle facial expressions. When you laugh, the muscles of the face are affected and change shape. The jaw, for its part, as has been said before, is capable of a variety of vertical movement. It is also capable of lateral movement, which directly affects the position of the mouth: in smiling, laughing, shouting, yawning, and so on. The powerful elastic muscles of the neck allow the head a considerable range of movement, depending upon their tension and relaxation. If the gesture is relaxed or tense, the neck will appear thinner or thicker, and the surface will appear smooth or the tendons will stand out.

MORE ON THIS SUBJECT

- Proportions of the Head **p.20**
- Basic Structure of the Head **p.30**

Light and Shade

The chin reveals its volume through the clean contrast of light and shade on the lower part of the face. If the direction of the light also comes slightly from below and from one side of the face, the lower jawbone can reveal its volumes, such as the chin itself, an element that can be turned into an item of primary importance in the characterization of the person being portrayed.

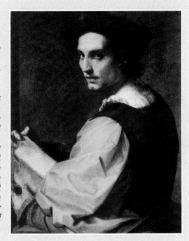

Andrea del Sarto (1486–1530), Portrait of a Young Man. National Gallery, London. This mannerist portrait shows the perfect treatment of the mouth, chin, and jaw by using the play of light and shadow. One can observe the detail of the cleft in the chin, an elementary characteristic of physiognomy.

THE HAIR

The character and shape of a head depend to a large extent on the hair, which can totally alter the external appearance. Proof of this is the importance that hair styling, shape, and color are given (especially by women). The hair is like a natural decoration for the human head. It has been seen as such by artists throughout history who have represented it in their portraits with particular care.

Form

Each person's hair has its own natural form: straight, wavy, curly, and so on. In addition to this, the form will also depend on the length and weight of the hair. Fine, straight hair will adapt itself to the shape of the skull more than thick, curly hair, which takes on a more solid, independent shape. The density of each person's hair must be taken into account in order to portray its form accordingly: smooth, silky hair needs a fine pencil or brush stroke; delicate strokes massed together will shape and interpret the hair form subtly; thick, abundant hair can be represented using blocks of different tones, depending on the color and illumination. The stroke and the intensity of the blocks of color are the two processes that are fundamental for giving hair form.

Tone

Light hair can be portrayed with more tonal contrasts than dark hair. Light hair will gleam more brightly where light strikes it directly, in contrast to areas that are not illuminated. Reflection and brightness can be portrayed with a few strokes of light and medium-light grays or even by leaving some parts white. A delicate touch in the degree of darkness or lightness is important, bearing in mind that one is not dealing with a solid object but with a sparsely filled volume and an irregular surface (in reality the appearance of a surface). The tone of the hair is a subtle interplay of values using graduations and diffusion to achieve the desired tactile qualities.

Relation to the Skull

Before beginning to draw the hair, the artist must have a clear idea of the nature of the head and the skull. The shape of the skull also determines the form of the hair. An initial linear framework of the hair should be based on the basic framework of the skull, as only in this way will the hair and the skull be properly integrated. However long the hair is, and however spectacular the hairstyle, it is necessary to start with the skull as this is where the hair starts, and it is from this that volume and form are created. Otherwise, the hairstyle could be too high, as if floating in the air, or too low, flattened above the face. If there is not much hair or it is very short, it will adapt itself to the line of the skull, following the surface with all its irregularities.

Hairstyle

The hairstyle can transform a face. One must always consider the characteristics of the model. A face without too much personality can be improved with a suggestive and spectacular hairstyle. If the lines and features of the face are small and smooth, a bright, voluminous hairstyle will create a contrast and give the subject an interest it was lacking. If the subject's

To portray the hair it is necessary first to create a linear framework that marks the outlines. Next comes the definition of light and shade, with the illuminated areas kept blank. Finally the transition between light and shade is softened to give a natural, light look to the form and tone of the hair.

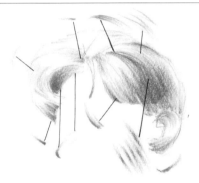

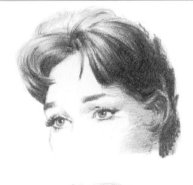

This illustration shows the type of strokes used for the areas of the hair. Each one of these strokes has a creative purpose, which is to say that it aims to portray the direction of the locks of hair.

face is marked and angular, it is a good idea to highlight it by simplifying the shape and minimizing volume of the hairstyle. In contrast, if the desired effect is to underplay the hardness of the face, it can be achieved by highlighting the hairstyle. This is particularly important with women for whom the type of hairstyle is a part of their personal image. A high hairstyle pulled back in a bun is suitable for the face of a mature elegant woman;

In the finished drawing, the darker strokes are perfectly defined against the lighter ones. With an eraser the light areas can be accentuated to highlight them against the dark areas.

a freer, looser, more "modern" hairstyle looks better on younger faces.

MORE ON THIS SUBJECT

• Proportions of the Head **p.20**
• The Female Face **p.22**

Face and Hair

A common error is to darken the tone of the hair uniformly, in contrast to the lightness of the face. The figure will appear to be wearing a wig, and the hair will not look convincing. The solution is to darken some parts of the face and lighten some parts of the hair, so that in any one area the tones of both face and hair are similar to one another. This will create natural transitions in the portrait.

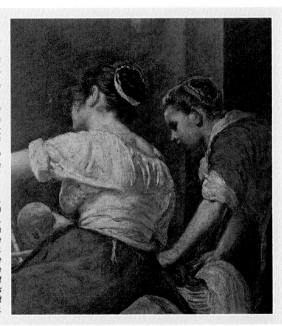

Velázquez (1599–1660), Las Hilanderas (The Weavers) (detail). The Prado, Madrid. It is clear that the main pictorial interest of these heads lies in their hair. Velázquez made use of this to show the exquisite contrast between the women's skin and the soft texture of their hair.

FORESHORTENINGS OF THE FACE

Once the measurements and structure of all parts of the face have been understood, it is time to look at the head seen from the side, above, or below in order to be able to draw it from all points of view. Because a foreshortened face is often more interesting than a view from the front or in profile, a good portrait painter should be able to represent the subject from any position. Foreshortenings should never be too exaggerated, unless you are attempting a dramatic or expressionistic portrait. To solve the problem of foreshortening, you must study what you can see carefully.

View from Above

On a face seen from a high point of view, the volume of the cranium, which is the part that is closest to the artist, stands out most. The concavity of the eyes makes them seem to be below the eyelids, and almost hidden by them. The nose will seem to stretch almost to the mouth and the mouth will seem small and thin. To draw everything correctly, you must imagine the nose to be a triangle seen in perspective. The ears will appear above the line of the eyebrows. In general, the form of the face will not be so round; the bottom half, around the chin, will tend to look thinner, transforming the head into a

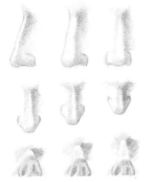

Foreshortenings of the nose, from the side, from above, and from below.

more than usually oval form. The most important thing is to draw the outline correctly, with a pre-

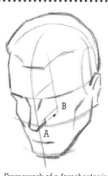

Framework of a foreshortening with the plane of the bottom of the nose (A) following the perspective plane of the line indicated with the letter B.

cise framework of the head, before carefully observing the details of the face.

View from Below

In contrast, when the head is raised, the most obvious parts are the jaw, the chin, and the mouth. The nose appears shorter and the nostrils can be clearly seen, giving the impression that they are joining the eyes. The eye sockets will be in an almost frontal position; the eyebrows will be further separated from the eyelids and in a much higher position. As the forehead is the part furthest from the viewpoint, it will also give the impression of being foreshortened, and both the hair and the cranium will be partially hidden. The ears will descend almost to the line of the chin. In the view from below, you must bear in mind the correct framework of the head and neck. No longer hidden by the jawbone, this region will be completely visible.

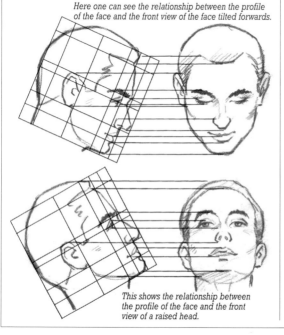

Here one can see the relationship between the profile of the face and the front view of the face tilted forwards.

This shows the relationship between the profile of the face and the front view of a raised head.

Lateral Foreshortenings

A slight turn to the side has always been the preferred pose of portrait painters in all ages. It is a position that allows the face to be seen completely, but which offers a subtle contrast of light and shade that enriches the personality of the subject. The portrait is no longer symmetrical because one of the sides is foreshortened and partially hidden. All the features on this side of the face will be fore-shortened: one eyebrow, an eye, and half of the nose will be almost hidden (except for the nostril), as well as half of the mouth. The part that is always hidden in a lateral foreshortening is one of the ears. The side exposed to the viewer (which is not foreshortened) will maintain a balance between the side view and the front view, and generally it is the side from which the light source comes, leaving the foreshortened side for the treatment of shadows—although this depends on the individual taste of each artist.

Foreshortenings

In the foreshortenings of the parts of the face mentioned above, you must always consider the characteristics of each model.

MORE ON THIS SUBJECT

· The Anatomy of the Head **p.28**
· Basic Structure of the Head **p.30**

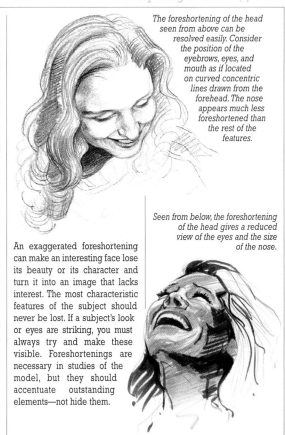

The foreshortening of the head seen from above can be resolved easily. Consider the position of the eyebrows, eyes, and mouth as if located on curved concentric lines drawn from the forehead. The nose appears much less foreshortened than the rest of the features.

Seen from below, the foreshortening of the head gives a reduced view of the eyes and the size of the nose.

An exaggerated foreshortening can make an interesting face lose its beauty or its character and turn it into an image that lacks interest. The most characteristic features of the subject should never be lost. If a subject's look or eyes are striking, you must always try and make these visible. Foreshortenings are necessary in studies of the model, but they should accentuate outstanding elements—not hide them.

Foreshortenings and Portraits

Normally portraits of the head are not violently foreshortened, for the simple reason that a portrait should pay attention to the facial features, and extreme foreshortening hides them. However, in almost all portraits there is a part of the physiognomy, albeit a very small one, that appears foreshortened. In the portrait from the front, the ears are fore-shortened, and in the three-quarter portrait (with the head turned to the side) the distal eye is foreshortened. The portrait of the profile, howev-er, does not have any foreshortening. For the beginner, this type of por-trait is usually the easiest to do.

In a lateral foreshortening, the face is defined by its profile, which is dominated by the curve of the forehead.

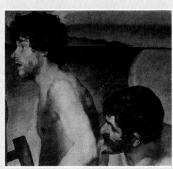

Velázquez (1599–1660), detail from Forge of Vulcan. The Prado, Madrid. This is an example of economy of means used in depicting a face with a dramatically emphasized foreshortening.

COMPOSING A PORTRAIT (I)

The composition of a theme on canvas or paper is a fundamental process that unites almost all the elements of a good portrait: pose, drawing, the surrounding objects, light, color, and so on. It is an essential factor for achieving a successful outcome, and consists simply in the ordered distribution of the elements of the painting to create a clear and convincing pictorial effect.

Studies for Composition

To study the model, the pose, the illumination, the situation of the artist in relation to the model, and so on, there is no better method than to take a notebook and make several sketches. Alter the pose and draw each sketch; maintain the pose and point of view, but change the framing; or vary the point of view for one or more different poses.

By attempting to find the best position of the model and of the framing on the paper, you are resolving a problem of composition. That is to say, you are attempting to resolve the order and proportions between the mass of the model's form and the available space; the amount of space the portrait occupies on the paper or the canvas; and the relationship between the white of the paper and the grays of the drawing, or between the background and the subject.

The visual center (B) of a space is slightly higher than the real or geometrical center (A), for which reason the head should also be raised a little. If the portrait is frontal, it should be centered horizontally (C). If the portrait is in profile (E) or is a three-quarters view (D), it is necessary to leave more space in front than behind.

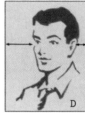

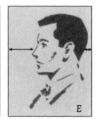

General Guidelines

The most common pose is for the model to be seated, both for a portrait of the head and for one of half the body. Whichever it is, remember that the height of the model's head should be at the same level as your head and, in particular, the model's eyes should be at the same height as your eyes. This relationship can vary if you want to achieve a particular effect. However, as a general rule, this position is the most usual. The model should feel comfortable, and his or her hair and clothes should be natural. This should enable you to work confident in the knowledge that you are not putting the model's patience or generosity to the test.

The Head Only

A composition of the head only is more frequent in drawing than painting; it is the usual choice for a drawn portrait, be it a sketch or a more finished piece. Isolating the head of the person being portrayed means limiting the representation of gesture and movement. At the same time it is necessary to fill almost all the compositional space, with the edges of the drawing extending to the limits of the page, as otherwise the head would seem strangely cut off at the bottom. A head alone seen from the front is a static composition, one that might suit

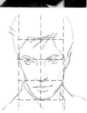

To compose a portrait correctly and carefully, follow a process of comparing distances on the real model, and then transferring them to paper. Imagine subdivisions of the face related to subdivisions that correspond to the format of the paper.

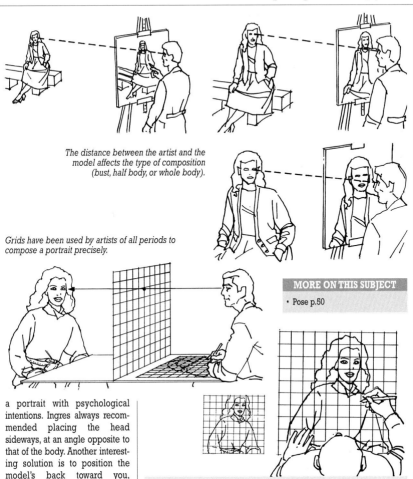

The distance between the artist and the model affects the type of composition (bust, half body, or whole body).

Grids have been used by artists of all periods to compose a portrait precisely.

MORE ON THIS SUBJECT

• Pose p.50

a portrait with psychological intentions. Ingres always recommended placing the head sideways, at an angle opposite to that of the body. Another interesting solution is to position the model's back toward you, with the head turned looking over the shoulder. This introduces a certain dynamism and naturalism that can be interesting.

The Profile

A portrait in profile allows for an interesting portrayal of the physiognomy and highlights the linear values of the drawing. Using the line of the profile, it is possible to create a likeness in a fairly simple manner, with little interaction of light and shade. In the composition of the profile what is important is the cleanness of the outline and the form, which stand out against the background.

The Visual Center

To portray the head alone, it is important to consider the place where the head is situated within the format of the paper or canvas. As a general rule, the head must by situated a little above the geometrical center of the paper. It is also advisable to leave more space between the face and the side of the paper closest to it than between the back of the head and the other side of the paper.

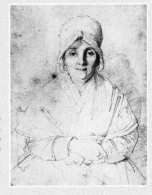

Ingres (1780–1867), Madame Ingres, Mère. Ingres Museum, Montauban. This pencil drawing is a perfect example of balanced frontal and symmetrical composition. Apart from the face, the rest of the drawing is just a sketch.

COMPOSING A PORTRAIT (II)

When the composition of a portrait has been resolved, one of the greatest technical obstacles has been surmounted. Situating the figure within the format, fitting it to the space available, deciding on the limits of the scene, and articulating the pose of the figure convincingly almost represent the definitive portrait. All these factors are a function of the type of portrait being produced and of how much of the figure will be visible in the finished work.

Busts

The portrait of the bust is one of the most classical options that can be adopted both for a drawing and for a painting. The composition of a bust is usually limited to the area immediately below the shoulders, or perhaps to the part above the waist. It is important to achieve a good relationship between the mass of the head and the volume occupied by the visible part of the body. One of the greatest advantages of this type of composition is the solid pyramidal distribution of the forms, supported by the wide base of the body and completed by the center of interest, which in all portraits is the head.

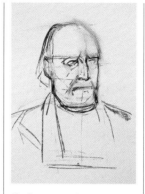

The features can then be sketched on the measurements established by the initial framework.

When the proportions of the compositional details are correct, one can begin shading.

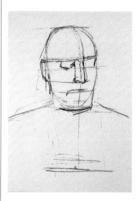

The process of composing and finishing the drawing of a bust. The process begins with sketching the framework and adjusting the proportions of the bust to the size of the paper.

MORE ON THIS SUBJECT
· Composition of the Portrait (I) **p.42**
· Pose **p.50**
· Gesture **p.52**
· Body Gestures **p.94**

Three-quarter Portraits

In the three-quarter portrait, the figure is visible as far as the legs: the thighs if the figure is standing or the area of the knees if the figure is seated. This is another of the classic compositions. It has the great advantage of being perfectly adapted to the long format that is common for portraits, with a harmonious relationship between the mass of the figure and the space of the background. In this type of composition it is likewise

The process of shading follows its course until the volumes and the interplay of light and shade show the likeness of the model.

advisable for the body, and particularly the head, to occupy a space that is slightly above the visual center of the picture. Again, there should be more space between the face and the edge of the picture closest to it than between the back of the head and the other edge.

Whole Body Portraits

The composition of the whole body is less usual. It raises certain difficulties stemming from the fact that the leg is a long form with a lot of space around it. The solution to this lies in choosing a format that is also long, or surrounding the image with a background composed of different elements. In this type of composition, particularly if the figure is standing, it is necessary to take great care reproducing the pose and the correct distribution of weight on the legs.

Size of the Support

Choosing the size of the paper or canvas depends entirely on the artist's intentions and the purpose of the painting. However, there is a general rule: It is not advisable to paint a human head larger than life-size. Nor should it be painted too small, as it is not possible to represent a likeness. If the head is painted alone, a size of 5 to 6 inches (12 to 15 cm) will be more than sufficient. The bigger the proportion of the body that is to be represented, the more the size of the head can be reduced.

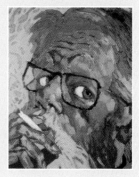

Sanvisens, Self-portrait. Private collection. By choosing a small format it is possible to achieve an effect of intense expressiveness without enlarging the head beyond life-size.

General framework of a three-quarter portrait. In this framework the divisions of the face are subject to the measurements and proportions of the rest of the body.

Shading can be introduced to give the details definition.

Composition and Format

The question of the format of the paper or canvas, and of the convenience of using certain specific measurements that link the dimensions of the figure being represented with the physical dimensions of the support, depend on the preferences and style of the individual. The format is part of the choice of composition made for each work. This choice should suggest the type of

format that is most suitable. If the portrait is to be formal or classical, the most typical format is long and not very big. It is possible that the figure has a special gesture or that it is necessary to

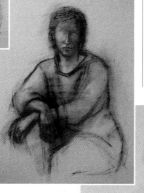

incorporate a suggestion of the atmosphere or of other figures, in which case a landscape format can be used. If it is a full-body standing portrait, the format will have to be long, unless the artist wants to include other elements in the portrait: different spaces, doors, bookcases, and so on. In the classical portrait, the composition is "filled" with the ample clothing of the subject. A modern portrait painter should use other resources, such as placing plants and objects around the figure.

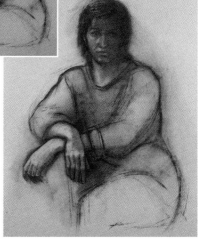

The finished drawing keeps the balance between the details of the face and the shaping of the rest of the body.

SELF-PORTRAITS

The self-portrait provides excellent practice for any painter, as it is not necessary to attend to the demands of a client or their notion of likeness. The artist can practice all kinds of solutions, run riot with color, distort and interpret any or all of the features, or opt for abstract versions of his or her own face. The only things the artist needs are a mirror and drawing or painting materials.

Partial Studies

The best way to produce a self-portrait is to begin with studies of your face, making notes and sketches that allow you to understand the form and proportions of your own features. In each of the studies a different solution can be found. It is pointless trying to attempt a definitive result: the expression will be different with each sketch and the proportions will vary, albeit only slightly. The important thing is to become familiar with your own features, in the same way that you would with any other model. From these partial studies, you can produce a synthesis that will provide a clear conception of your image.

Point of View

In a self-portrait, the point of view is as important, or more so, than in a portrait of another person. When using a mirror, you must first consider how to work

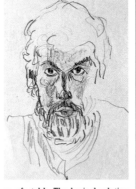

In this study by Armengol, the artist is attempting a graphical synthesis based on the accumulation of stokes.

Self-portrait by Lluís Armengol made after trying out various alternatives in previous studies.

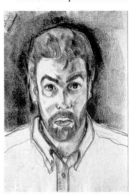

comfortably. The logical solution is to place the mirror to the right (unless you are left-handed) in order to see the mirror with a simple movement of the eyes. The mirror should be at the same height as your gaze, although it is

Study for a portrait by Lluís Armengol. This partial study explores the expressive effects of chiaroscuro.

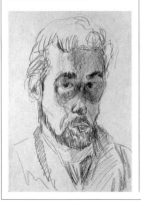

Self-portraits as Self-knowledge

The list of great painters who have investigated the expression of their own face is endless. Some, like Rembrandt or Van Gogh, did so on numerous occasions, driven by insatiable curiosity to understand themselves. This knowledge took a wide range of guises, and it is not surprising that artists adopted somewhat theatrical poses in order to see themselves as they would really like to have been. However, in most cases these self-portraits are unflinching documents of the artist's awareness of him- or herself.

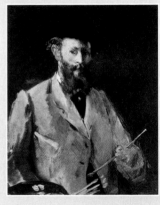

Edouard Manet (1823–1883), Self-portrait with Palette. Artists have made the self-portrait the medium of psychological introspection as well as a form of stylistic investigation.

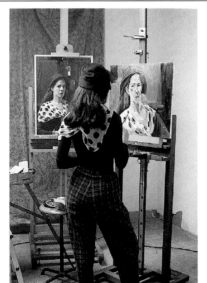

It is usual for the artist who wishes to produce a self-portrait to place a mirror at the height of his or her eyes, at a distance of no more than 3 feet (1 m). It is important to remember that the image of the self-portrait should be a reflection of the painter in the mirror. Trying to produce a literal representation can make the work dull, as the artist would have to adopt a rigid pose that would be incompatible with the dynamism of the painting process.

MORE ON THIS SUBJECT

• Basic Sructure of the Head **p.30**
• Composition of the Portrait (I) **p.42**
• Pose **p.50**
• Drawn Portraits (I) **p.60**

produce the whole form more or less simultaneously. Whichever is the case, one of the advantages of the self-portrait, already mentioned, is that it allows you to work freely, without any kind of constraint. For this reason it is advisable to approach the subject without any previous preconceptions and with a maximum of liberty.

Expression

Expression is one of the factors that best lends itself to being studied by means of the self-portrait. In the self-portrait you can adopt a variety of gestures and expressions, study their characteristics, and portray them to your liking, emphasizing features as you wish. By making faces in front of the mirror you will be able to understand the movement of the face and the origin and physical causes that lie behind the expression of various different feelings. This is one of the many things that make the self-portrait one of the most exciting forms of the genre.

always possible to place it at a different height to obtain a point of view from above or below. The distance at which the mirror is located will also affect the result. If it is placed very close to you, the face will occupy most of the composition. For compositions in which another part of the body has to appear, the mirror should be placed approximately 8 inches (50 cm) away. The further away the mirror, the greater the amount of the body that will be

visible, and therefore that can be included in the self-portrait.

Possibilities

In the process of creating a self-portrait, you may begin by defining the facial characteristics and then resolve secondary aspects. Alternatively, it is possible to begin a general outline and leave the features for later. The usual course is to find a balance between both options in order to

The initial draft of a self-portrait can only be made with the confidence that comes from having made previous sketches and studies.

This self-portrait by Esther Olivé is the result of the correct positioning in front of the mirror, which allowed for comfortable working and suitable composition.

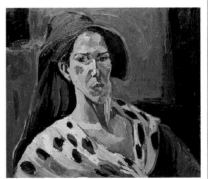

GROUP PORTRAITS

The group portrait is the most ambitious manifestation of the genre. To approach it with any hope of success a painter needs to have experience in painting portraits. This type of portrait requires a strong vision of the whole and a subordination of the individual in favor of the overall scene.

Groupings

A group portrait is above all an arrangement of forms, a collection of volumes united by light. Seen in this way, a group portrait is similar to a still life. In a certain sense, the similarities are very close from the point of view of form. In an individual portrait, the painter is faced with a single shape with distinctive character-istics that have to be portrayed in a unified way. In a still life, the artist has to find and also create the pictorial links that unite the different independent objects. For this reason, seen from the point of view of composition, a group portrait imposes certain formal considerations that are unlike those of an individual portrait. The basic objective of the composition of a group portrait is to achieve a good arrangement, a distribution of the figures that brings out the individuality of each person but always subordinates it to the vision of the whole. The most monumental groupings in the history of art were painted

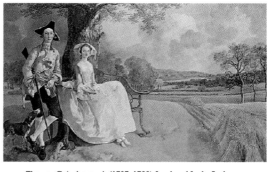

Thomas Gainsborough (1727–1788), Lord and Lady Andrews. *National Gallery, London. The couple in the portrait are located to one side in a daring distribution of the elements of the portrait.*

during the Gothic and Renaissance periods, when patrons commis-sioned large-scale compositions filled with figures. Modern painting (bourgeois painting, canvas painting) is radically different, much more individualized and less monumental. Nevertheless, painters like Rembrandt, Frans Hals, Monet, Renoir, or Fantin Latour produced memorable group portraits whose characteris-tics can be looked at from a modern perspective.

Composition

The pictorial focus of a group portrait can be approached from different points of view. The figures can be posed or can be depicted performing some activity or other. The former situation is more usual, and the painter must find a way of achieving poses that are natural, uncomplicated, and harmonious with one another. A very common solution is to seat the models around a table, as if they were making conversation after a meal. This has the advantage of reducing the portraits to compositions of busts. It is important that the busts are not all in the same position: one should be seen from the front, another in a three quarters view, and another in profile. In any case, it is not advisable to undertake compositions of more than three people. With more than this num-ber the technical difficulties increase enormously. Three figures naturally produce a com-position that is both symmetrical and pleasing at the same time. (Two figures make symmetry obligatory; more than three lead quickly to disorder.)

Rembrandt (1606–1696), Syndics of the Amsterdam Drapers' Guild ("The Staalmeesters"). *Rijksmuseum, Amsterdam. Traditional collective portraits became works of art thanks to the careful distribution of the figures into a unified whole.*

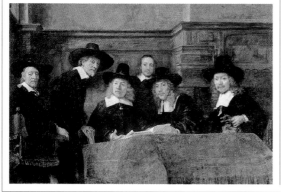

The initial sketch of a group portrait must, above all, deal with the harmonious distribution of the figures.

The overall coloring should give the same treatment to all the figures, without making the characteristics of any of them stand out.

Vision of the Whole

The vision of the whole should be present throughout the production of a group portrait. The artist creates the work as a whole, without concentrating on just one figure in particular and ignoring the others. In this way the composition advances as a single unit and not as the sum of its parts. To work in this way it is necessary to overlook, at first, questions of likeness and expression and to concentrate on the formal aspects of the composition—the contrast between figures, the relationship between the postures of each figure, and the coloring of their flesh tones. Only when these aspects are satisfactorily resolved can the artist address the details of characterization of each of the figures.

Characterization

Once the whole group has been developed to the same level of representation, the artist can approach the task of characterization without fear of losing sight of the work as a whole. In this final stage the artist can explore on the details both of physiognomy and of clothing, developing each figure one by one until they all reach a level that is desirable, accurate, and unified.

The result of this group portrait by Miquel Ferrón shows the detailed finish and unified treatment of all the figures.

Unity of Flesh Tones

In a group portrait it is necessary, above all, to achieve unity. For this reason, the artist must make use of a certain degree of generalization in the characteristics of color of each figure, giving each of them a similar tone for their skin. Using the same chromatic range and working on all of the forms simultaneously, unity can be guaranteed.

Raphael (1483–1520), Portrait of Pope Leon X with Cardinals Giulio de Medici and Luigi de Rossi. Uffizi Gallery, Florence. The strict limitation of the palette to reds and the warm colors present in the skin tones gives a masterful pictorial unity to this group portrait.

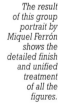

MORE ON THIS SUBJECT

· The Golden Age of the Portrait p.12

POSE

The pose of a portrait can be a position adopted spontaneously by the model that the artist then sketches in order to elaborate on it later. In the majority of cases, however, the artist has to study different possibilities before deciding on the one that is most suitable. This study should take into consideration different factors concerning the character of the subject, his or her age and sex, and the artistic effect that the painter wants to achieve.

The Subject's Character

The artist must bear in mind the character of the model before deciding on the pose of the portrait. This character is both the artist's personal creation and the manifestation of the subject's personality. In some styles of painting, the expression of the face will contain a good part of the interest of the picture. If this is reinforced by the position of the arms and hands, the angle of the trunk, and so on, then the portrait will become a homogenous and convincing whole.

In other, more abstract styles of painting, the expression does not depend so much on the facial characteristics as on line and color. In these cases it is equally important to study the type of pose, given that the harmony of line and the elegance or crudeness of shape depend on it. In general, one can state that the poses that best bring out the character of the subject are those in which he or she appears most natural, with a characteristic gesture of the arms and hands pointing towards the viewer. The way of sitting or of placing the hands must be characteristic of the model. The artist should only interfere to give the model confidence, and not to impose a particular pose. If the artist knows the model well, he or she might suggest a characteristic pose: a typical gesture, a certain angle of the head, a particular way of sitting or leaning.

In older people, the interest of the portrait returns to the facial features; the face shows all its expressiveness and it is barely necessary to complement it with gestures or characteristic movements. These gestures, in mature or elderly people, should be minimal, discreet, and of secondary importance.

Another study of the child in a different pose.

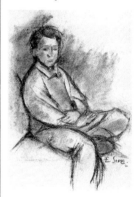

Pose According to the Age and Sex of the Subject

When the model is a child, it is logical for the pose to be restricted or rather static, without harsh contrasts and without too much dynamism: one that best expresses a child's natural, unostentatious grace. In portraits of young people, the painting should show a certain dynamism in pose, in the way of sitting, and in the position of the arms and hands. The interest of the portrait can move from the face to the elements of gesture that show the character and the physical presence of the person.

Poses of children should be informal and static, but not rigid. This is an example of a possible pose for a child.

A preliminary study for the previous pose. These studies are a way of making the pose more suitable for the figure to be portrayed.

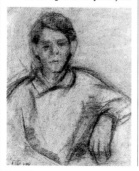

The final result of the portrait of a child produced by Esther Serra. This pose is a variation of the previous studies.

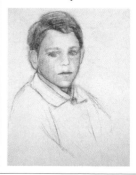

Contrapposto

Contrapposto is the contrast between the directions or angles assumed by different parts of the body. Artists make use of contrapposto to achieve pleasant poses and to avoid figures appearing too straight or severely immobilized. For the art of the portrait, contrapposto should not be too forced and should never involve contortions. Within the discreet limits of acceptable dynamism, it is interesting to consider the poses in which the subject's head and trunk face in different directions, for example, by having the trunk in profile and the head facing the front, or vice versa. Such basic contrapposto should be achieved with coherent positions of the arms and hands. In the case of full-body portraits, the possibilities of the contrapposto are multiplied. The artist must pay close attention to the concordance of the disparate parts of the whole, making sure, for example, that the position of the legs supports the body convincingly, and that the distribution of weight and tension is correct.

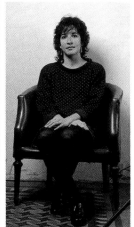

These three photographs show different poses for a model. They are variations on the same idea. Variations of this type are what the artist should consider before making a definitive decision.

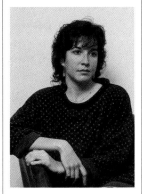

The Study of the Pose

Before beginning any portrait it is indispensable to study the pose by producing several quick sketches. The artist must ask the model to adopt different positions, to cross his or her legs, to lean back comfortably, to sit in different ways. Each of these poses should be sketched and examined for compositional possibilities. The head requires separate sketches, seen from different points of view and positions. These are combined with previous studies of the bust or the whole body and analyzed. Foreshortenings should also be studied closely, given that it is not advisable to improvise them on the definitive work. For this reason, consideration of the pose requires studies of the whole as well as partial sketches, which will smooth the way toward the definitive portrait. These drafts will permit the artist to see which is the most harmonious and suitable pose for fulfilling his or her intentions.

The Active Figure

The artist who knows the personality of the subject well can suggest a specific pose or ask him or her to perform a characteristic activity. The best choice is an everyday activity, such as reading a book, writing, or doing some domestic task. In this way the artist can endow the portrait with a visual impact that defines the subject at the same time as it gives the work pictorial dynamism.

The person in this portrait by Vicenç Ballestar is represented in a pose that indicates his profession. This possibility gives added interest to a portrait, an interest that is both pictorial and thematic.

MORE ON THIS SUBJECT

- Composing a Portrait (I) **p.42**
- Gesture **p.52**

GESTURE

Gesture forms an indivisible part of pose; in fact, it is not possible to think of a characteristic gesture dissociated from its pose, and vice versa. Gesture, however, does convey information about the personality of the subject of the portrait, which simple pose, being more impersonal, cannot transmit alone. Each pose can be accompanied by as many different gestures as the people who adopt it. The artist must identify the individual characteristics of the pose in order to clearly express them in the portrait.

Hand Gestures

In contemporary painting, hand gestures have lost much of the great weight of significance that they have had at some periods in the history of art (for example, the Gothic period). Nevertheless, they still retain their own expressive value. We know that certain movements and gestures of the hands have a precise significance: elegance, tiredness, determination, humiliation. The painter must be aware of them and give the model precise instructions so that the hand gestures are in tune with the chosen pose. If the figure is relaxed, the position and gesture of the hands should avoid all types of tension and complication: it is necessary to chose the most simple, logical gesture for the occasion. If the figure is active, holding some object or performing some activity, the artist should be careful to choose and represent the correct gestures; the hands should give the impression that the subject is actually holding the object in question.

Drawing Hands

The hands are anatomically complicated, for which reason it is always very important to draw an overall sketch of the volume they occupy, and then to fill in the detail of the fingers and palms. It is also essential to remember the proportions and anatomical relationship of all the elements. Start by considering the bones, which affect the hand's outward appearance and are visible beneath the surface of the skin far more clearly than in any other part of the body. The great number of large and small bones in the hand must always be linked to the metacarpus (the wrist) and with the knuckles. It is very important to maintain correct proportions for the knuckles and joints of the fingers. This can be accomplished by means of more or less concentric circles whose center is approximately the wrist. In any position, these circles

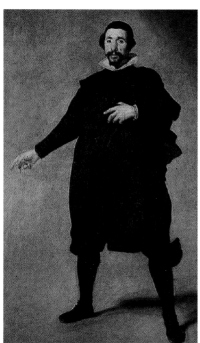

Velázquez (1599–1660), Pablo de Valladolid. *The Prado, Madrid. The theatrical gesture defines the character and gives him personality.*

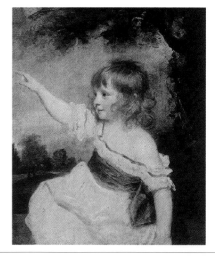

Joshua Reynolds (1723–1792), Master Hare. *The Louvre, Paris. Gestures should always be correct for the age of the portrait's subject. The expression and movement of the figure in this painting are unmistakably childlike.*

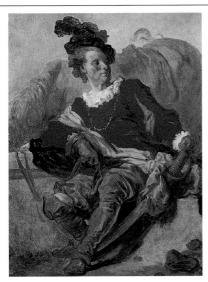

Jean Honoré Fragonard (1780–1850), Portrait of the Abbot of Saint-Non. *Legado Cambó, Barcelona.* The social position of the subject and the desire to show this through gesture are clear in this portrait.

convincing arrangement of the parts of the portrait, so that the gesture being represented (apart from the verisimilitude of the facial features) is correct for the subject of the portrait. This depends directly on the physical proportions of the portrait's subject and his or her customary way of sitting, moving the head, placing the hands, and so on. For the portraitist, the first thing to do is to study these physical proportions in order to reproduce the subject's characteristic gestures artistically.

Velázquez (1599–1660), Las Meninas *(detail). The Prado, Madrid. The expressiveness of the hands is achieved with a masterly economy of means.*

should serve to provide a framework for the foreshortening or perspective of the hand; they are a great help for linking the joints to one another.

Sketching Gesture

To capture the gesture of a subject, observe the position of the hands and arms. Study them carefully to understand their form and the reasons that determine their position. If you can see the limbs as a series of linked cylinders and joints, and the hands as flat endings to these limbs, you will begin to understand the movement and pictorial meaning of the gesture in the portrait. Having made a correctly proportioned, more or less geometrical sketch, you can then incorporate the characteristic details of the hands' anatomy, as well as chiaroscuro, and values of volume. Practice drawing your own hands and arms in as many different positions as possible until you have gained the necessary familiarity and confidence to portray the gesture of the subject.

Characterization

By characterization we understand the qualities by which the viewer can recognize the portrait's subject (if he or she already knows the subject), or can recognize in the portrait a concrete person and not just a generic figure. A portrait of this type is described as "well-characterized." That is to say, the characterization becomes a synonym for likeness. However, in another sense it refers to the

The Emphasis on Characterization

Ingres used to tell his pupils, "Capture the individual character of your model; if it is a strong man, don't just make it into a likeness, capture his Herculean nature as well." All good characterization involves emphasizing the predominant aspect of the subject, such as his or her strength, fragility, ingenuity, and so on. This aspect is easy to discover in a person, but it can only be reproduced in a portrait if the artist slightly exaggerates the factors that define it (fatness, thinness, elegance).

Edgar Degas (1834–1917), Study of Heads. *Bibliothèque National, Paris. This magnificent study in characterization shows great powers of observation.*

MORE ON THIS SUBJECT

• Pose **p.50**

CLOTHING

Drawing clothing or drapes is an academic discipline, currently in decline, which traditionally was obligatory for all students of drawing. Considered an end in itself, the exercises were designed to teach the student to show differences in fine forms using light and shade. It is not necessary to go to such extremes of perfection, but the art of the portrait always requires the artist to be able to follow the logic of folds and creases in the subject's clothing.

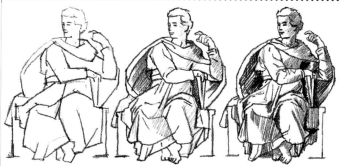

In order to study clothes and clothing, first it is necessary to produce a frame-work of the general volume, and then to graduate the values of light and shade, as well as the main creases and folds.

The Importance of Material

Drawing clothing can be seen as an authentic abstract exercise, given the geometrical implications suggested by the material's folds, and its relative independence of anatomical forms. In this sense, it is useful to practice drawing clothing: the general problems of drawing (chiaroscuro, outlines, shaping) appear in their barest form. However, what makes drawing material a useful skill is that it allows the artist to understand the logic that controls the configuration of the folds in the subject's clothing. Furthermore, the folds and creases have their own compositional interest because, in certain cases, they permit the artist to balance the pictorial space by compensating for the solid volume of the forms of the figure with a network of lines that can be more or less complicated.

Coherence of Folds

Whether the portrait is completed in one session or worked on over a period, the artist must assume that the position of the model will never remain static.

With each small movement the clothes change their appearance: some folds will be different, the sleeve might appear shorter, the hat more tilted. The painter should never be confined by these superficial variations in clothing. The portrait is his or her creation; it depends on the artist and not on the transitory appearance of the details of the subject. To ensure the sustained control of a work, it is useful, on the one hand, to fix the pose in the painting as soon as possible, and on the other hand, to have a deep knowledge of the logic of folds and creases of clothing so that they do not depend on slight superficial variations.

The key to this is to see and understand clothing as a harmonious whole, to build a framework of the entire garment. to define the different directions in which the clothing falls, to identify the most significant folds, and to use light and shade to express the principal masses. Once the study of clothing has been mastered, it must be remembered that the attire should not hide or confuse either the anatomy or the gesture of the person. Rather, it should help to explain them. Too many creases or overzealous reproduction of the fine points and details can confuse and hide the anatomical structure that sustains

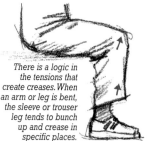

There is a logic in the tensions that create creases. When an arm or leg is bent, the sleeve or trouser leg tends to bunch up and crease in specific places.

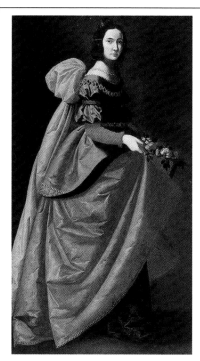

Francisco de Zurbarán (1598–1664), Saint Casilda. *The Prado, Madrid. This is a sumptuous example of how folds can become the absolute protagonists of a work of art.*

MORE ON THIS SUBJECT

· Accessories **p.56**

it. The secret consists of understanding the pose of the body, carefully creating a framework of the forms, and synthesizing the folds and creases of the clothing. To achieve this synthesis it is necessary to identify those folds that best define the form of the body they are covering (for example, the gesture of an arm, the angle of a leg), remembering that creases and the form in which the folds are distributed follow the logic of the angles and twists of the different parts of the body.

Simplifying Clothing

The interest of the clothing is not simply academic or realistic, but rather deserves special attention from the artist. It is not necessary to reproduce exactly all the folds and the light, shade, and reflections as was the case traditionally. The painter can interpret clothing in an abbreviated, simple way, following the degree of detail that the secondary elements of the portrait require for his or her artistic style. A more or less abstract configuration of folds invites a free interpretation of form and color once the essential problems of the construction of the figure and the composition and coloring of the work in general have been resolved.

Clothing and Arabesques

The folds and creases of a figure's clothing can be an excellent excuse for creating an arabesque that enriches the decoration of the work. The arabesque is the decorative quality by which line stops being purely descriptive and creates rhythms and configurations of great visual interest. These can be created in the form of folds and creases, providing a beautiful counterpoint to the sober description of the subject's facial features.

John Singer Sargent (1856–1925), Lady Agnew of Lochnaw. *National Gallery of Scotland, Edinburgh. The folds can be a good excuse for the elegant treatment of form.*

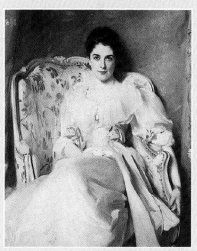

The Color of Clothing

The color of the model's clothing is very important both from an artistic point of view and from the point of view of characterization of the figure. The tonality of the clothes can emphasize or obscure the expression of the face. In the same way, they can provide a very interesting decorative element: the variety of folds can be enriched by the intricate design of a pattern and the vivaciousness of the coloring, creating a pictorial center of attention.

Leonardo da Vinci (1452–1519), Study of Clothing for a Seated Figure. *The Louvre, Paris. This study was executed with all the painstaking skill of a great master.*

ACCESSORIES

It is always possible to produce a portrait with nothing added, drawing or painting the bust or the head of the person against a neutral background. But all artists have been intrigued by the pictorial and expressive possibilities of locating a subject against a personalized background with the accessories that are closest to his or her character. These can create an atmosphere or scene that reveals something about the personality of the person being portrayed.

The Surroundings of the Portrait

In traditional sessions of life drawing that take place in art schools, the model poses on a dais surrounded by spotlights and with a minimal complement of a cloth, cushion, or item of furniture. The surroundings are severe and contain what is strictly necessary to optimize the visibility of the figure, while eliminating elements that might distract the attention of the student. All this is designed so that the exercise can be performed rigorously, in accordance with the demands created by the academic establishment. The figure could be a statue, which would not alter the essence of the exercise: the artist would represent the anatomical lines and volumes in the same way as with a live model.

When the artistic intention of the portrait is more important than the technical exercise, the painter seeks surroundings that will enhance the artistic treatment of the work, and which correspond to the personal reality of the individual being portrayed.

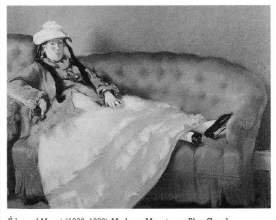

Édouard Manet (1832–1883), Madame Manet on a Blue Couch. *The Louvre, Paris. In this painting the color of the couch is a fundamental accessory in the chromatic harmony.*

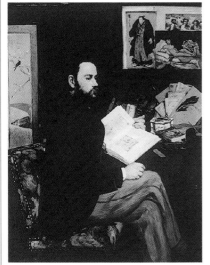

Édouard Manet, Emile Zola. *Musée d'Orsay, Paris. What is almost as important as the subject in this work are the personal surroundings that suggest associations with his profession and personality.*

Scenery

The concept of scenery might seem a bit theatrical and artificial. Some painters reject this idea and choose to remain faithful to the natural surroundings of the figure, without adding or removing anything. However, even these artists would agree that not everything should be painted in every situation, and that certain subjects demand to be portrayed using a specific chromatic range or specific surroundings. There is nothing wrong when an artist creates the scenery for a portrait: a small, fictional world that will facilitate the other fiction which is the painting itself. These scenic fictions can be created with furniture (a chair or a sofa on which the model appears seated), or by placing the subject in front of a window or balcony, by adding spotlights that complement the natural lighting, or by placing flowers or fruit in the scene. If the chosen

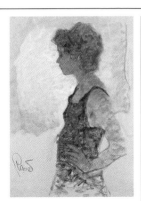

In this pastel by Joan Raset, all accessories have been dispensed with, but the luminescent atmosphere plays an important role in the romantic suggestiveness of the work.

surroundings are in the open air, then the color of the sky, clouds, plants, and the light and shade of nature can be introduced with complete freedom.

Chromaticism

The coloring of the surroundings affects the appearance of forms in general, and of the portrait in particular. Returning to the example of the life class, the location of the model is designed so that the body will be perfectly contrasted and isolated from its surroundings, which are converted into a simple backdrop without distracting accessories. Normally, art schools tend to surround their models with neutral, somber colors, which neither stand out nor divert the attention of the students. However, in the artistic interpretation of a portrait, the colors that surround the subject can provide a special atmosphere. This might be suggested by the chromaticism of the figure itself, as well as his or her clothing. The sensitive artist should be capable of inventing tones and colorings that help to envelop and highlight the expression of the subject's face. If the artist also adds the scenery with chromatic richness, the suggestive power of the portrait is increased.

Intimist Painting

Intimist painting, as its name indicates, deals with private themes close to daily life and personal surroundings. Although examples of this type of painting can be found within different

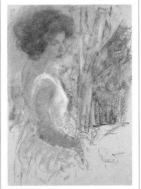

The vaporous nature of the curtains make them accessories that fit the mood of this figure drawn by Joan Raset.

MORE ON THIS SUBJECT

· Clothing **p.54**

styles and periods, the clearest evidence of painters who practice this kind of art can be found among the work of some of the Impressionist and Postimpressionist painters of the end of the nineteenth and the beginning of the twentieth centuries. These artists approached the portrait from an intimate point of view, placing the subject within his or her personal and familiar surroundings, and removing all effects and ostentation. This intimacy is the best means of achieving surroundings based on accessories from the life of the subject, on objects that surround him or her, and on his or her daily atmosphere. Intimism favors naturalism and is opposed to the rigidity of poses that are too solemn or affected.

Interiors

The best selection of accessories are those that can be found in the places where the person being portrayed lives. If the subject is being portrayed in the artist's studio, the artist can create the correct atmosphere with a small scene containing the objects that are most suitable to the personality of the model. They should not be complicated objects: some flowers, books, or some decorative detail could be sufficient to suggest personal surroundings and to complement the composition of the work.

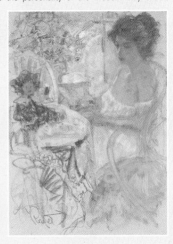

This work by Joan Raset creates a small, barely suggested scene based on daily objects fused with the atmosphere of the surroundings.

ILLUMINATING THE PORTRAIT

Light affects both the form and the color of a portrait. Poor illumination can not only ruin the final effect of the portrait but also the work of the artist. Light allows the artist to achieve different pictorial effects according to its intensity, direction and the reflections it creates on the face. Each artist develops his or her own preferences, and these can have a powerful impact on the works produced.

Natural and Artificial Light

The difference between natural and artificial light is essentially that the former varies constantly and, if it comes from a window, is usually soft and balanced. Artificial light, in contrast, is rather more defined and allows the model to be illuminated by changing its intensity easily, in any direction desired and without any kind of variation. Artificial illumination is perfect for drawn portraits and can also be useful for painted portraits, although in this case natural light should be considered as well. Artificial light should not be too intense, unless the source of light is placed a long way from the subject.

Direction of Light

Light can illuminate the model from above, from below, or from the side; it can be located behind the subject or can illuminate the subject from the front. With frontal light, shadows almost disappear, the volume and feeling of depth are lessened, and the color of the face itself stands out fully.

Frontal illumination creates a single plane, with little suggestion of space. The figure appears against a background that barely features the interplay of light and shade.

Lateral illumination creates chiaroscuro. The forms are outlined by the light, and some are confused with the background.

This pose, illuminated from the side, avoids sharp contrasts on the front of the face. It contains plenty of atmospheric suggestiveness thanks to the particular illumination.

The previous pose is now illuminated from the front, making it lose volumetric force and achieve a greater clarity of form.

Marià Fortuny (1833–1874), Male Bust. Museum of Modern Art, Barcelona. This shows a strongly contrasting lateral light source that creates harsh, deep shadows to provide a dramatic effect.

By moving the light source to the side, shadows begin to appear, the relief of the volumes is created, and the form reveals itself clearly in areas of light and shade. In an extremely lateral position, the light leaves the far side of the figure in darkness, and volume and relief are principally revealed through projected shadow. Seen against the light, the forms of the figure show their outline with a characteristic halo and the volumes acquire a weightless appearance. If the figure is illuminated from above, the projection of the forms accentuates the effect of relief and creates a somewhat phantasmagorical appearance, similar to that produced by a light projected upwards from below. Of all these possibilities, it is generally best to choose the least extreme (slightly lateral) illumination that will reveal the features but not distort them, although it is always interesting and advisable to investigate the possibilities that exaggerated or unusual illumination offers.

Reflected Light and Projected Shadow

As important as the effect of direct illumination on a figure is the effect of reflected light and of projected shadow. These are ever-present in reality: all objects are subject to reflections and shadows, which alter their color. The same occurs with the figure: if it is illuminated exclusively by a single light source it would look artificial. The colors that surround a figure project their shadows and reflections onto it. The light creates harmonies and unexpected results, is reflected on the surfaces of objects, illuminates the face from very varied angles, and creates shadows that alter the continuity of the forms being illuminated. Although this could seem a drawback, it can be transformed into an advantage if the artist follows the play of light freely, interpreting projected shadows and reflections daringly and looking for variety and dynamism of color in them. If the artist accepts this richness that nature is providing, he or she has much to gain: vitality and the life of the subject in its true surroundings.

MORE ON THIS SUBJECT

• Painted Portraits (II) **p.66**

Finding Illumination

Richness of reflection and shadow can be created by surrounding the model with vividly colored elements. These surfaces will affect the color of the skin and load it with fresh nuances and colorings. The reflection of light on a blank sheet will lighten the shadows; if the sheet is red, the shadows will be tinged with red and will shade the face of the model. In the same way, if an object breaks the path of the light, its shadow will be projected onto the figure, creating an effect that might confer interest to the portrait. The key is to combine light and shade with complete freedom, avoiding the schematic effect of a single, static light source. The quality of the illumination can be enriched until the accumulation of shadows and reflections becomes reasonably complicated. Many painters prefer to use a simple, indirect source of illumination, but it is worth experimenting with new possibilities of light and color. Often an artist can come across solutions he or she had never thought of and which are no less original or effective for having been unforeseen.

Chiaroscuro

Chiaroscuro applied to a portrait is one of the most dramatic forms of illumination, given that it concerns the contrast of light and shade with no other extenuating factors. In such cases, the color becomes of secondary importance, there is no room for nuance, and everything is resolved with contrasts. More than a portrait of physiognomy, the portrait in chiaroscuro is a work of dramatic expression.

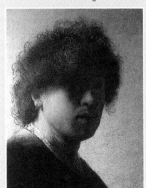

Rembrandt (1606–1696), Self-portrait. Rijksmuseum, Amsterdam. A masterful example of chiaroscuro that gives dramatic shape to the physiognomy and creates clear psychological suggestion.

DRAWN PORTRAITS (I)

A drawn portrait can consist of a simple sketch or a work that contains all the factors of likeness and expression demanded by good portraiture. The result will vary according to the technique chosen. The portrait can be linear, almost flat, or can be volumetric with abundant shading and shaping.

Lines and Blocks of Color

The media available for a drawn portrait range from traditional charcoal to Chinese ink, and include sanguine, colored chalk, graphite pencil, and colored pastels. The artist can use these media in a linear way, leaving the line to explain form, or can use blocks of color to create volume and shape. The former technique is the simplest and also the most abstract of those available to the artist. Working with lines means being sensitive to contours and also to spaces (the areas without marking), and to the suggestive-ness of lighted areas. Working with blocks of color means giving priority to volume, the graduation of shading, and the three-dimensional effect produced by means of values and modeling.

Chinese ink allows the artist to work with lines (using nibs or pens) or with blocks of color using brushes.

Chalks and sanguine are ideal media for portraits. They produce better results when they are used on colored paper.

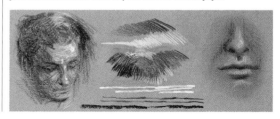

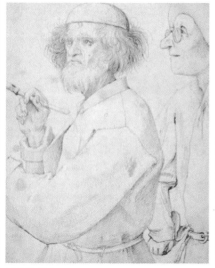

Peter Brueghel (1525–1569), The Painter and the Critic. Albertina, Vienna. Line alone can carry all the expression and facial details of a portrait.

Values

To consider values it is helpful to forget color and think purely in white, gray, and black. Taking this monochrome scale as a base, it can be said that values are tones, or to put it another way, that they are different intensities with which the tones are presented. Each intensity of gray that can be distinguished in a monochrome scale going from white to black is a value. In this case, they are values of gray; taking any other monochrome scale, one can talk in terms of the values of red, green, blue, and so on. Light and shade, in a drawn portrait, are represented by means of values that increase or decrease in intensity according to the way in

which they pass from light to dark and vice versa. This can be seen if one looks at a portrait in charcoal. A portrait created using this technique is one in which the artist has worked by concentrating purely on the effect of black and white. Chiaroscuro consists of working with values of light and shade and resolving the movement from maximum light to maximum shade by means of the scale of grays. This scale should be extensive enough for the transition to be made smoothly and without harsh, sudden contrasts.

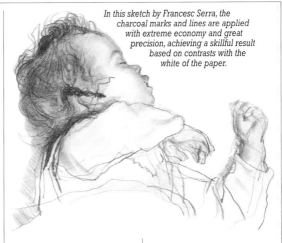

In this sketch by Francesc Serra, the charcoal marks and lines are applied with extreme economy and great precision, achieving a skillful result based on contrasts with the white of the paper.

Modeling

Modeling is the direct consequence of the evaluation of light and shade in a portrait. The word recalls the work of a clay sculptor and the task of creating volumes. Something similar happens in the chiaroscuro treatment of the figure: the more intense the chiaroscuro, the more contrast there is between the light and the dark values, and thus the greater the sensation of volume and the more obvious the effect of light on the figure. In the same way, the greater the contrast between light and shade, the greater the number of intermediate values required for the forms to present a continuous surface. Particularly in the case of the rounded figure, in which the transition from maximum light to maximum shade is smooth and progressive, a sudden interruption of the transition will give the effect of an outline or edge.

Warmth of Stroke

The simplest method of drawing—with sanguine, pencil, or charcoal—can produce great results in portraiture. However, the artist must use the medium with energy and sensitivity, giving the stroke as much importance as possible, seeking values and suggestions of light, shade, and volume.

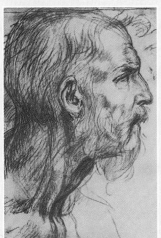

Andrea del Sarto (1486–1531), Head of an Old Man. Uffizi Gallery, Florence. The accumulation of charcoal strokes uses the contrast between light and shade to create the characteristic expression of the old man's face.

Modeling and Creating Value

Although they seem like very similar concepts, creating value is not exactly the same as modeling. Modeling consists of creating a closed, uniform volume, but it is possible to create value without modeling a form completely. When one tone is contrasted with another (the tone of the figure being portrayed contrasted with the background, for example) the artist is creating value but not necessarily modeling. Value can be created with flat areas of shading that contrast with one another to a greater or lesser extent. When the artist creates various different contrasts on the paper he or she is creating value in the composition without needing to model its volumes. The artist introduces the contrasts necessary for the spatial effect to work visually. A portrait can give the feeling of space and relief without including modeling, but it would never be able to give this sensation if there were no values, in which case the drawing would appear to be completely flat.

MORE ON THIS SUBJECT

• Composing a Portrait (I) **p.42**

DRAWN PORTRAITS (II)

Given the importance of toning and modeling in drawn portraits, it is also necessary to consider the possibilities of pure line in the resolution of the physiognomy and the other factors that affect a portrait. Lines have a life of their own which the artist must empower, highlighting certain outlines and looking for the graphic and dynamic possibilities of the theme.

Line Portraits

In general, drawings are produced using lines. These can be continuous or discontinuous, simple (exclusively limited to the lines of the portrait's contour) or elaborate. In any case, what is important is that the form of the figure is well constructed. A portrait executed using a long, continuous line demands careful previous observation of the model and a detailed study of its outlines. The execution should be rapid because the fluidity of the line does not allow for hesitation. There is also the possibility that this line will lose its continuity and will be linked to other lines superimposed on it, in which case each one of these lines should maintain a certain interest and the whole must give the portrait a suggestion of dynamism and life. Because the profile and the full-body portrait present great richness of outline, they are the types of portrait best suited to the line technique. The broken line technique, in addition to producing results that are visually very attractive, has a high pictorial interest. Unlike outline drawings, which are enclosed by a single line, it leaves open various options for further elaboration of the form. When one considers the drawing as an end in itself and not as a prior step to working in another medium, the line is even more important given that it is the only medium being used: the line, in this case, must explain everything.

MORE ON THIS SUBJECT

• Self-portraits p. 46

Descriptive Lines

Descriptive lines are those whose sole aim and function in the drawing is to define the outline of the form. These are the

The line is the most usual resource used to begin a portrait. This preparatory sketch by Lluís Armengol was executed with a few well-distributed lines.

As the work advances, the artist develops blocks that suggest volume and describe the distribution of light and shade.

lines that reveal with greatest clarity the personal vision of the artist and the essence of his or her style. In the words of Degas, the drawing "is not the form, but rather the vision and understanding of the form." For this reason, the descriptive lines are not ones that copy the outline of the portrait exactly; rather, they are the ones that produce a creation that arises from the artist's sensitivity towards the portrait. These lines should have their own interest, personality, and originality: this is the opposite of the dryness of academic drawing, which only strives for an exact copy.

Lines on Paper

All artists are aware of the value of the line as an independent element. You can perform a very simple test to prove it. Take two sheets of paper and draw a portrait (or a self-portrait) from memory on each of them, quickly,

The result of the drawing is a combination of blocks and lines that have a great artistic and dramatic effect.

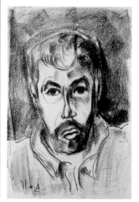

Here Armengol has begun a self-portrait by blocking in the head without any definition of detail and with clear expression of volume that is almost sculptural.

quality of the drawing. In this respect, it must be remembered that the artist is not a photographer, but instead is expressing a personal vision. The line must emphasize the main outlines, define the composition, mark the patterns, and show the facial expression.

Decorative Lines

All lines, sometimes even the most descriptive, should have a certain decorative component, not in a gratuitous, unjustified, or mannered sense, but to decorate and enrich the surface of the paper, to possess an independent value as a rhythmic form that combines with other forms.

In practice, it may be necessary to limit the decorative possibilities of a line to give it functionality and descriptive sense in the representation of the features. However, the secondary aspects of the composition, such as clothes or accessories, can always be handled decoratively. The hair of the subject is one of these possibilities: the waves of the hair lend themselves to creating free, linear, imaginative rhythms. In the same way, the elements that surround a portrait can be used: flowers can be suggested using a few scribbles, as can the pattern of a cloth, an armchair, or the movement of some curtains.

without thinking, and using very few lines. One of them will always be more interesting than the other and will always have a line or a group of lines that are more deft, more full of life, and more suggestive than the other lines. This artistic virtue of the pure line must be present in all drawn portraits. The delight of a portrait's curves and sinuous contours, for example, must be shown and emphasized with clarity in the lines of the drawing. This expression sometimes demands certain exaggerations, simplifications, or other changes, which it is reasonable to make if by doing so it is possible to intensify the visual

The process of the drawing is based on intensifying the initial masses, while searching for the essential volumes of the physiognomy.

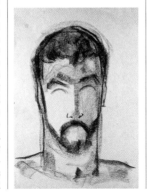

The result is a self-portrait in which nothing has been resolved by lines and which has a great precision of form and outline.

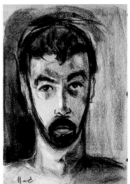

Media for a Line Portrait

The usual media for a line portrait are a graphite pencil and Chinese ink drawn with a nib. In both cases, the artist is obliged to make maximum use of the line. These two processes can produce results that are truly artistic, if the artist using them bears in mind their limitations. In the same way, portraits can be executed using lines drawn with charcoal or pastel, provided the artist manages to synthesize the form using few lines.

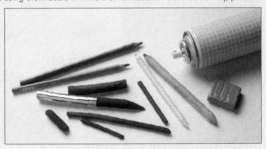

Charcoal and graphite pencils can be used for drawing lines as well as for blocking in areas.

PAINTED PORTRAITS (I)

In order to create a painted portrait it is vital to understand the dynamics of color, of contrast, and of the consonance and dissonance between tones. A painter can use a very limited palette, if he or she is interested in values or an extensive range of tones, or if he or she is aiming for a purely colorist work. In both circumstances, the artist must investigate the possibilities of each technique.

The Value-based Portrait

Reiterating what has been said about values in the pages dedicated to light and shade, it should be repeated that values are variable intensities, either lighter or darker, of the same color. Painting a portrait based on values means restricting one's chromatic range to a highly reduced series of colors, which can be extended by lightening or darkening the tones.

The painter starts with a basic color, which he or she lightens or darkens to produce values of the same color or very similar colors. This type of painting tends to emphasize the physicality of its volumes and the intensity of the modeling; portraits painted in this way have effective chiaroscuro, which makes them stand out against the background as emphatic forms.

Many of the great masterpieces of portraiture produced since the Renaissance have emphasized values, which might explain why this approach remains extremely influential and popular today.

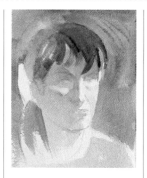

The foundation of a value-based painting starts with the establishment of the forms within a limited chromatic range.

The Colorist Portrait

The tendency towards colorism in the portrait was introduced definitively by the Impressionist painters. These artists sought complete chromatic fullness, escaping from the exaggerated chiaroscuro of academic painting. They wanted to express all the splendor of nature solely by means of color.

Colorism consists, in general terms, of converting lightness and darkness in a portrait into different colors and not into values of the same color. Colorism avoids the use of black as a darkening tone and looks for darkness in blues, greens, and purple colors; at the same time bringing out light tones by means of yellows, oranges, or light

Joan Raset, Prone Figure *(detail). Private collection. Pure colorism can give brilliant results, as in this work in which light and shade are treated as saturated tones.*

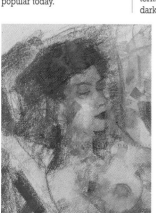

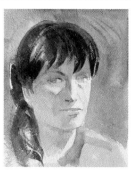

Continuing within the range already chosen, the modeling is developed using a lightening and darkening of the colors, without adding new chromatic elements.

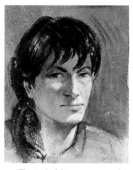

The end of the process consists of refining the modeling in order to create the characteristics of the physiognomy.

grays. The painter works by expressing the nuances of color to which the light and shade of the figure tend, depending on whether they are warmer or colder, more green or more blue, exaggerating them where necessary in the search for maximum chromatic intensity. It is not a case of looking for a color that is closest to reality, but of the artist choosing those colors that best express its feeling.

Volume and Color in the Portrait

Choosing between value-based volumes and areas of color is a personal matter that depends on temperament. The decision, however, is irrevocable. The artist can practice both techniques according to the model and the mood at the time, choosing between one and the other with complete liberty—provided he or she does so fully aware of the reason, and knowing that each of them gives different, sometimes even contrasting, results. The portrait can be done in one or the other of the two ways and the results can be equally interesting. A chiaroscuro treatment tends to give priority to sculptural form, relief, and the three-dimensional aspect of the portrait. The colorist technique, in contrast, tends to be flat, with areas of flat color, contrasts in color, and an absence (either total or partial) of volume and sculptural spatiality; in this case color is the sole protagonist.

Warm Colors and Cold Colors

Contrasts in colors create a sensation of space on their own.

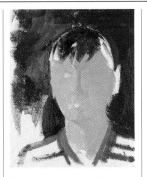

The process of the colorist portrait begins by laying down bright colors corresponding to the essential forms of the composition.

To be more precise, the contrast between two colors suggests a distance between them; there is always one that appears closer and another that appears further away. This suggestion of distance is even greater when a warm color is contrasted with a cold one; the warm color appears closer, the colder one appears further away. All portrait artists know this effect well and use it in their work. If the artist wishes to highlight the portrait in the foreground, he or she can do so by using intense warm colors (oranges, ochres, reds) and by

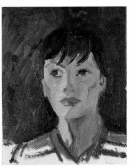

The initial colors are enriched with new tones that bring out the colorist harmony and which make the features concrete.

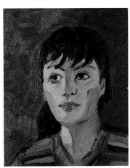

To achieve overall coherence, the saturated tones should be harmonized using intermediary tones that give unity to the forms of the portrait.

contrasting them with cold colors in the background (grays, blues); these cold colors recede visually into the background. This is one of the ways of creating a spatial sensation without using perspective. However, it is possible to try solutions based on having cold colors in the foreground in order to achieve less original effects.

The Idea of the Chromatic Range

A chromatic range is composed of colors that are harmonically consonant with one another. Among the infinite variety of possible ranges, it is possible to distinguish three basic groups: the range of warm colors, the range of cold colors, and the range of broken colors. The first group is composed of yellow, ochre, orange, and red tones. The cold group consists of bluish grays, blues, most greens, mauves, and some violets. The broken group is composed of grayish tones that occupy a place halfway between the other two groups.

Chromatic ranges are selections of harmonic colors that share a common warm, cool, or broken tendency.

MORE ON THIS SUBJECT

· Composing a Portrait (I) **p.42**
· Flesh Tones **p.68**
· Expressive Color **p.70**

PAINTED PORTRAITS (II)

On these pages we consider questions of contrast between the figure and the background. These are problems of space, of the creation of distances, and also of how to achieve pictorial unity in a portrait. Thanks to simultaneous contrast and to the contrast between the figure and the background, it is possible to create a sensation of space that is natural and pictorially valid.

Simultaneous Contrast

The effect known as simultaneous contrast consists of lightening or darkening a color as a consequence of its contrast with an adjacent color. If a light gray is surrounded by a dark blue, it will appear almost white. Conversely, if a carmine tone is surrounded by black it will appear lighter than if it were surrounded by white. The more different tones used in a portrait, the more contrasts of this type will be created. This effect allows the painter to intensify colors or to soften them by means of their adjacent tones.

Emphasizing Outlines

Thanks to simultaneous contrasts the painter can emphasize and highlight the outlines of a figure being portrayed without having to enclose it in a dark outline, which often gives a form rigidity. It is enough to lighten the colors of the background around the darker limits of the portrait and darken them around the lighter limits. By surrounding the outside edge of a light shoulder with a dark color, the outline is created without the need to draw it; the same happens when the tone bordering a dark area is lightened. In this way, the drawing and the coloring form an inseparable unit: the lines come from the colors. This is particularly useful for achieving chromatic continuity and preventing colors from being interrupted by unnecessary lines or strokes. Within simultaneous contrast one must mention the possibility of emphasizing the intensity of a color by locating it next to its subdued complement. For

example an orange tone will be emphasized if it is bordered by a light grayish blue; a red will be emphasized if it is placed next to a dull green, and a blue will be more vibrant next to a pale yellow.

All portraits should start from a good sketch, like this one by Joan Martí drawn with chalk, as it is the indispensable first stage before adding color.

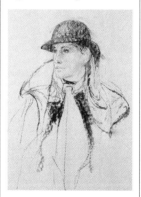

The contrasts of color are vital, even in a work with a softened range of tones like this one. The red of the scarf adds a vibrant note to the composition.

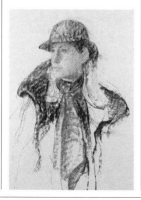

Figure and Background

The use of simultaneous contrast as a recourse for defining the outline of a figure without using lines is very useful as long as it does not become overly systematic. If the figure being

The first skin color is added with a single tone, aiming for smooth contrasts between the darkness of the blocks of color that surround the face and the color of the skin.

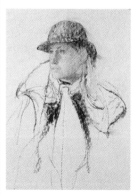

The result is one of great harmony. The contrasts of tone are perfectly balanced with the contrasts of color.

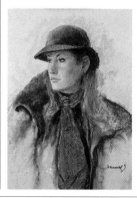

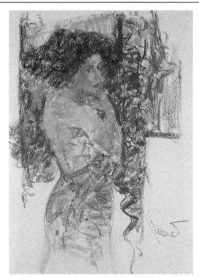

The contrasts of pure color can suggest a space in a way that is analogous to the evocation of space produced by the contrasts of light and dark tones.

MORE ON THIS SUBJECT

· Composing a Portrait (II) **p.44**
· Flesh Tones **p. 68**
· Expressive Color **p.70**

is because forms close to the eye, which are darker or lighter than forms further away, seem to have a greater contrast. A consequence of the previously mentioned simultaneous contrast, this factor can be combined with the contrast between warm and cold colors to create a realistic pictorial space for the portrait.

If the artist is not using chiaroscuro, which creates space by means of shades and graduations of color, the expression of depth has to come from the interaction of colors. Generally, this is done by contrasting soft colors with intense ones, using the combination of complementary colors that the eye of the viewer interprets as a spatial distance between the foreground and the background.

portrayed is enclosed on all sides, it will be drowned out and will look artificial. It is very important that the simultaneous contrasts should give way to fusions between the figure and the foreground in some areas; that is to say that the color of the figure should be merged with the color of the background in some parts. In this way the artist will ensure that the figure and the foreground are integrated into a single unit. The foreground will be seen as a space occupied by the figure, not as an independent plane on which the portrait is superimposed but in which it does not participate. This is fundamental; some portraits are unsuccessful because of the lack of interaction between the figure and the space it is occupying.

Space and Contrast

A good way of introducing the feeling of space in a portrait is to contrast the intensities of color. These contrasts have to be energetic or they will be lost among the nuances of color. For example, a very dark form against a light background "advances" towards the foreground; in the same way, a very light form against a dark background also seems closer. This

Atmosphere

There is another method of creating space in a portrait. This is through the suggestion of atmosphere achieved by means of the softening of certain outlines, avoiding perfect definition of the features. This resource can suggest a diffuse light in an interior or the presence of mist between the figure and the viewer. These effects are easily adapted to romantic interpretations of the portrait.

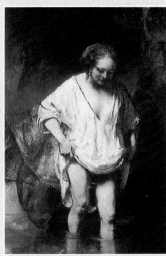

Rembrandt (1606–1669), Woman Bathing. National Gallery, London. Atmosphere is an essential factor that can be achieved using soft transitions of light and shade, as well as vibrant tones against a neutral background.

FLESH TONES

Flesh tones are a central problem in the art of the portrait. The tones of any color of the skin are not easily defined and change according to the conditions of light, and the age and sex of the model. Skin tone is something each artist creates individually. Adapted to each specific work, there can never be considered a perfect, universally valid tone for the skin.

Skin Color

Someone with little artistic experience might believe a skin color exists that can be applied to portraits without further complications beyond those of spreading them on the paper or canvas. With the exception of industrial paints (for advertising posters and similar productions) and in clothing manufacture, universal skin colors do not exist, just as "sea blue" does not exist. The sea, like the human skin, does not have a specific, fixed color; in the same way the skin tends to pinks, ochres, siennas, and ivory tones. All these are weak colors in the warm range. However, the makers of paint for artists do not offer premixed skin colors because they know that it is the artist who creates them in their work. This creation is what is known as a flesh tone. According to the style and the chromatic range that each artist uses, skin colors can vary considerably.

Pastel colors do not have to be mixed. Special ranges for flesh tones offer a great number of choices.

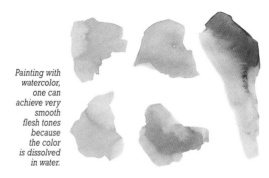

Painting with watercolor, one can achieve very smooth flesh tones because the color is dissolved in water.

MORE ON THIS SUBJECT
- Painted Portraits (II) **p.66**

Options

Each artist has a tendency to interpret flesh tones in a personal way. When rendering Caucasian skin, for example, some painters start with an orange-tinged ochre, a flesh tone that is fairly intense as a base color. Others prefer a basic flesh tone that is lighter, such as a pink that is almost white, so that it can be darkened where it is shaded with greens and pale blues (for light shading) or with reds and carmines (for darker shading). The Impressionist flesh tones of Renoir or Cezanne, for example, are a wonder of nuances in which everything from violets to vermilions can be seen, passing through grays and oranges. It is sufficient to look carefully at them to see that there is no such thing as a universal skin color. Pictorial flesh tones are free interpretations of the qualities of the skin under the effect of light.

Some characteristic skin colors are achieved by mixing ochre, red, sienna, and yellow.

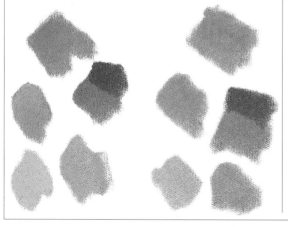

Sanvisens, Self-portrait. *Private collection. The flesh tones always depend on the chromatic harmony chosen. In this case the color of the skin is emphasized by the blue background.*

Light and Shade

The flesh tones of a portrait should always aid the expression of light and shadow on the subject's face. Shadows can be thick and dense or clear and transparent, and light can be intense or filtered. In addition, flesh tones vary according to the tones that surround the face. Working on a tonality based on gray, it suffices to use a light warm tone (a light sienna, for example) to make the flesh tone stand out with an almost tanned intensity against the background. This intensity can later be softened or heightened by surrounding it with other colors that highlight the flesh tones (surrounding it with an intense red, the same flesh tone would appear pale). The color of the skin is softened, corrected, or intensified according to the vision of the actual figure and the harmony created in the picture. If, on the other hand, the portrait is painted against a warm background, it would be sufficient to treat the flesh tones with very pale pinks, a little yellow, or even with white.

Flesh Tones and Chromatic Ranges

A range of plausible flesh tones is one in which ochres, siennas, and earth colors are combined to form a base for the modeling of the face in chiaroscuro, and to which accents of pure, vibrant color, such as intense vermilions, yellows, blues, and reds, are added with the aim of making the areas of maximum light stand out. But bear in mind that the most intense tones should be used with care to avoid effects that are too dissonant. Another possibility would be to manipulate the colors that surround the face so that, by the effect of simultaneous contrast, the flesh tones are given value. A face surrounded by grays and blues will always appear warmer than another contrasted with reds and yellows. In any case, the best course is to consider the color of the skin and the color around it together.

Flesh Tones and Pictorial Techniques

Ranges of pastel color are available in special selections for painting flesh tones. They are usually ochres, reds, and browns, generally broken colors. In pastels, the colors are already prepared; all that is necessary is to choose and combine them. For oils, watercolors, and acrylic media, the only way to create the correct color is by means of various mixtures. These can be based on ochre, orange, and white, and can be given nuances using blue or some green tones.

Vincenç Ballestar, Portrait of an Old Woman. *Private collection. In this watercolor, the flesh tones are given subtle values using transparent and superimposed colors.*

EXPRESSIVE COLOR

After having carefully studied the use of color, contrast, modeling, line, and value, and after having considered the orthodox ways of achieving likeness in a portrait, it is necessary to look at the possibilities offered by working spontaneously. It is important to know the rules, but there must always be room for intuition and inspiration—which work beyond the rules.

Chromatic Invention

More than any other aspect of artistic creation, color is tied to imponderable factors by theory, factors that are impossible to classify in rules and laws. It is often the case that the intuition of the moment gives the artist an unexpected solution not previously considered, and which improves the work. It might happen that what had seemed like a pink flesh tone is expressed much more energetically with a light green, a color that had not entered into the artist's calculations. At such moments of true inspiration, the painter should forget theories, rules, advice, and previous intentions, yielding instead to his or her pure chromatic instinct—the inventive sense of color. This sense cannot be taught and belongs exclusively to each individual artist. Some artists have a highly developed sense of color, and in others it is more modest.

The colored stroke, which goes beyond delineation and modeling of the anatomy, is a fundamental expressive factor in this work by Joan Raset.

Whichever it is, comparing one colorist spirit with another is extremely difficult: some painters employ an abundance of colors and others use the quality of a few colors creatively arranged in perfect harmony. The only advice that can be given is to have confidence in your own abilities, allowing yourself to be carried away, according to the situation, by the instinct and enthusiasm of creating.

Visual Intensity

One of the primary objectives of any work of art is its attractiveness and the sheer visual intensity

Sanvisens, Self-portrait. Private collection. The desire for expression that is not strictly descriptive can be seen in the chromatic energy of this portrait.

Direct Mixtures and Impasto

While working quickly in any pictorial process, the treatment of color should be much more spontaneous and direct. When painting with oil, the portrait worked on directly develops impastos and thick lumps of color that emphasize the physical act of painting and give the portrait great expressiveness. Mixing color directly on the support, in any medium, is one of the basic resources for an intuitive manner of approaching a portrait.

Badia Camps, Figure in an Interior (detail). Private collection. In Badia Camps' pictorial style, colors are directly mixed on the canvas according to the immediate perceptions of the painter standing before the model.

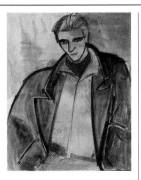

The process of a portrait painted by Esther Olivé illustrates the characteristics of the expressive interpretation of color. The work begins with a free, spontaneous laying down of the essential chromatic relationships.

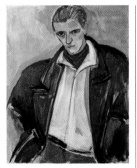

The colors are established more solidly in the search for more energetic contrast.

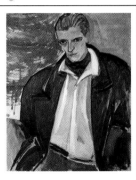

The relationships of colors are intensified as the work progresses, independently of the subject's real coloring.

it transmits to the viewer. This intensity can come from pure color, as was well known by the inventors of abstract painting. Those pioneers discovered that a painting can have its own life without having to represent real objects, but simply by developing its coloristic possibilities to the full. The lesson of those masters is applicable to the portrait, and it is possible to introduce beautiful colors into a picture without fear of their being excessively intense. This should not be done gratuitously or blindly, but must correspond to a valid internal impulse. This impulse cannot be falsified: when it really exists, it is always felt. Technical knowledge is fundamental and practice is vital. Without them, there is no way of achieving good results. However, one must not forget that painting portraits should be a pleasure—not a boring routine. If the artist has painted in a routine way, the portrait will not hide this. If it has been executed with pleasure and enthusiasm, this pleasure and enthusiasm will transmit itself to the viewer.

Rapid Painting

In the past portrait painters employed specific ways of preparing the canvas, painting the background, laying down the dark

In the final result, the strength of color is emphasized by the expressive intention of the brush strokes.

tones first, working painstakingly on color that was already dry, all of which obliged them to work slowly. Since the nineteenth century, painting has become more and more immediate and even deliberately unreflective. Because they wish to express their own personality and affirm their own style without prejudice or convention intervening, contemporary artists often choose not to meditate but just to paint. On other occasions a more or less impressionist style of using color directly to capture an instant of atmosphere and light on the face of the subject obliges the painter to work rapidly.

The chosen medium will also have an influence on the rhythm of work. Oil and pastels allow all types of rhythms, but in general watercolor demands rapid execution. In any case, to produce rapid painting, it is necessary to establish the basic relationships almost without corrections. If, on

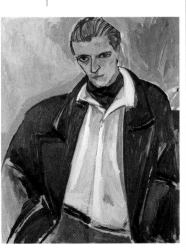

the other hand, the artist wishes to work slowly, he or she should meditate on each stage, always thinking about what should be done next to improve or modify what is happening at the time. Whether the process is slow or fast does not mean more or less work, but just a different way of seeing and interpreting.

MORE ON THIS SUBJECT

· Pose **p.50**
· Painted Portraits (II) **p.66**
· Flesh Tones **p.68**

THE STUDY OF THE FACE

PRODUCING A DRAWN PORTRAIT

The concepts dealt with in the preceding pages are here put into practice in the execution of two portraits of children, made with charcoal and with colored pencils, which exemplify not only techniques employed, but also show some useful methods that make the work easier.

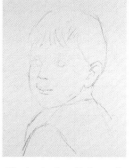

A photograph with guidelines, either directly marked or superimposed on tracing paper, provides a good introduction to drawing portraits.

After drawing the guidelines on the drawing paper, it is easy to reproduce the basic lines of the portrait.

The initial shading is added with the help of the references obtained from the guidelines.

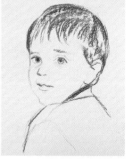

Approaching the Subject

As an introduction to producing a drawn portrait, you can begin with an exercise that consists of tracing a photograph. Tracing is not the correct word; in fact, the photograph and the tracing paper are used as tools to solve, for the moment, such practical problems as the need for someone to pose patiently for you. By placing a sheet of tracing paper on top of a photograph and dividing the image into a grid, you obtain a perfect guide for the drawing. By taking a sheet of drawing paper that is divided in the same way as the initial grid, it is possible to produce a framework for the portrait easily by following the guidelines of the photograph on the tracing paper. The important thing is to understand that the use of the grid is confined to comparing distances and dimensions precisely instead of doing so approximately. With this method all that is necessary

is to count subdivisions instead of finding the relationships by sight, then framing and sketching the form and features of the portrait. It is necessary to draw the defined outlines, placing the basic lines and marking the shadows. Remove the grid after you have noted all the references. Now you can work with a thick charcoal to highlight the shadows. The strokes of the charcoal can be smudged with the fingers to create values and modeling that reaffirm the volume of the face. When the drawing is heavily marked with large masses of charcoal, it is possible to recover the light areas. Simply erase part of the charcoal to create reflections and highlights. At the end of the process, draw significant details, such as eyelids, the opening of the lips, the pupils, and the more delicate shading.

When the guidelines have been erased, the artist continues the work of shading and shaping shadow without the need for precise references.

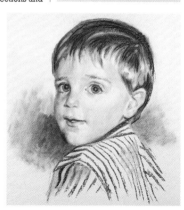

MORE ON THIS SUBJECT

· Drawn Portraits (I) **p. 62**

Drawing with Colored Pencils

Photographs provide a very useful stepping stone to working from life. Colored pencils are a very quick, easily-worked medium with which it is possible to get excellent gradations of value and subtle modeling of a portrait. Start by choosing a range of pencils composed of warm and cool tones, and begin to work with a couple of mid-range colors (brown, maroon, or sienna), which act as a base for subsequent work. The initial strokes should be handled very carefully: they should define the different directions of the hair, the form of the eyes, the structure of the face, but you should work with the pencil very lightly, caressing the paper, tracing lines without exercising any pressure. In this first phase it is necessary to concentrate on the oval of the face and on the delineation of the features. Once the likeness has been established, you can add other colors in order to increase the general toning. This is a technique that requires calm and patience. Two basic issues should be remembered: on the one hand, to draw strokes that always allow the earlier colors

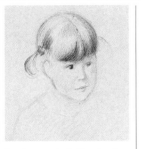

Drawing a portrait with colored pencils requires a slow, careful process, beginning with soft strokes that establish the basic chromatic intonation.

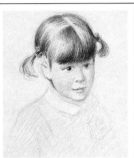

Following the initial selection of tones, the strokes of color are intensified, and new tones are superimposed over them.

The final result is a smoothly harmonized chromaticism that is well suited to portraits of children.

to be seen; on the other, to apply the strokes following a logical direction that will explain the structure of the face. The procedure involves constructing the volumes with gentle light and shade, so that there are no harsh contrasts, and alternating

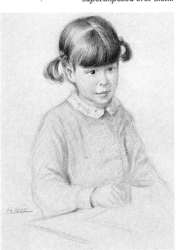

warm, more or less dark colors. It is important that at no point is the silhouette defined with a single stroke. The face and head should join with the background of the paper almost invisibly, so that it is not possible to determine precisely where the background begins and where the form ends. The figure should be integrated in the atmosphere of the whole. In this way the effect will be much more real and alive.

Once the whole has been achieved, with all its parts perfectly related, the details can be filled in by shading the relief of the ears, defining the eyes, and highlighting the shine of the hair. This simple technique will lead little by little to a result that combines the virtues of the drawing with the subtlety of coloring.

Media and Results

Each drawing medium brings about a different result. The artist who is familiar with the different media used for drawing will know which ones are best adapted to his or her style, temperament, and work habits. Charcoal is cruder than colored pencils. Although the quality of the finished work is independent of the method used, the medium with which the artist is most comfortable will, in the last instance, decide the choice.

Chalks and hard pastels are very effective media for drawing portraits.

PRODUCING A PAINTED PORTRAIT

Whichever technique is chosen, painting a portrait requires the artist to pay simultaneous attention both to shaping the image and to the pictorial effects that are achieved on the support. However, this latter area is where everything depends on the method being used. Each technique has its own logic and the artist must recognize it.

Watercolor Portraits

Watercolor is a medium that is suitable for painting loosely and rapidly, and expressing contrasts of light and color. It is not ideal for painting a portrait if the desired effect is of a perfect finish. Because watercolor does not allow for corrections, execute a few primary sketches before starting to paint. This will help decide color and composition, and will also familiarize the artist with the model.

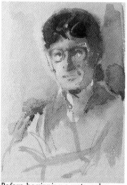

Before beginning a watercolor portrait, it is worth producing rough preparatory drafts in order to foresee the effects of transparency and luminosity.

Watercolor begins with the pencil framework of the lines of the composition in a pyramidal structure, depending on the type of composition and the naturalness of the pose. The initial stage of the drawing is also executed in pencil, working on the lines established by the framework. With another, lighter pencil it is possible to mark the limits between the large areas of light and shade and add the details of the face.

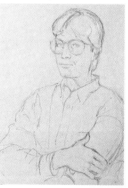

From what is suggested by the initial drafts, the drawing of the figure is made according to the chosen composition.

The nuances that watercolor permits are extremely subtle and should be calculated before being applied.

Flesh Tones

The initial blocks of color begin with flesh tones. In the demonstration on this page, this tone is produced by mixing oranges with vermilion, a very warm color that determines the general intonation. The shadows are also warm, but are composed of fairly dark tones of sienna. The necessary compensation of cold colors is provided by grays and the occasional mauve situated in the center of large blocks of shaded flesh tones.

The richness of the flesh's transparency should be linked to an equally rich treatment of the face and hair; if they are resolved independently, the results are always unsatisfactory. The hair and the face should always be differentiated and at the same time should flow into one another at some point on the face. When the general blocking of color is complete, it is necessary to work slowly, respecting the basic colors until the definitive coloring is achieved. The final moments involve the finish of clothes and hands, which are virtually accessories within most compositions.

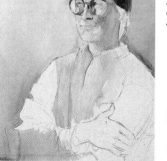

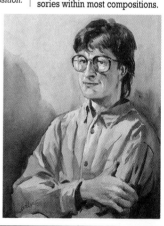

The result is a work of high pictorial quality, obtained by giving expression to all the qualities of luminosity and transparency that watercolors alone can provide.

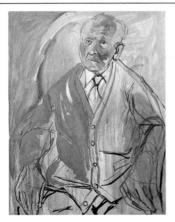

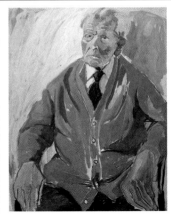

Oil paints permit a more confident treatment of a portrait, with room for correction and a certain degree of improvisation.

After producing a basic framework of forms and tones, the oil portrait demands energetic elaboration and strong contrasts.

MORE ON THIS SUBJECT

• Painted Portraits (II) **p.66**

Oil Portraits

Oil painting technique favors a free, confident style, with which one can improvise, develop, and add detail to small parts of the composition. The starting point for an oil portrait can be a few lines on a base of very liquid color. These can be in a blue tone, and in any case should be darker than the background coloring. Once the initial framework has been established and the composition of the figure has been fixed, color can be added, starting with approximate strokes that harmonize with the flesh tones. Oil paint should not be reworked in areas that are

When all the coloring is coordinated, the result is one of intense artistic power.

already covered with different colors. Because oils dry slowly, there is the risk of dirtying the coloring that has already been established. The best solution, in the case of major corrections, is to scrape away the paint or wait until it is dry.

Evolution of the Process

The density and opacity of oil colors mean that the paint gains texture as the process of its elaboration advances. In the event that the figure contains energetic contrasts of warmth and coolness

(warmth for the face and coolness for the clothes), the background should be painted in pale tones that do not run the risk of causing disharmony. Naturally this tone should be varied in intensity and intonation according to the tones of the figure: where a profile should be highlighted, the contrast should be greater. It is also necessary to darken the background color in the areas where the figure's shadow falls.

The process continues until a good balance is achieved between the fluidity of the painting process and the degree of detail achieved. If the fluidity causes any confusion, the painting should be worked on further. But under no circumstances should the detailing be taken to the point that it drowns out the vitality of the portrait.

The Problem of Finishing

All real objects contain too much information, and no painter can express their full richness, even less so when the subject is a human figure or the expression of a face. The moment of completion is a determination that should come from the work process itself. No one can tell an artist when the work is finished; the artist him- or herself will realize it alone. When the portrait does not "demand" anything further, when there is harmony throughout all its parts, then the work can be considered finished.

The finish of a painted portrait is a function of the personal style of the artist, and what he or she wants to obtain from the model: a few blocks of color can define a form and "finish" it.

LIKENESS

An eternal problem of the portrait is its likeness to the model. Without some form of likeness, the portrait is not a portrait. However, this alone is not enough to make a portrait a pictorial, artistic work. The production of likeness involves looking at a small range of essential factors, without which it is impossible to talk of a true portrait.

The Problem of Likeness

The question of likeness is an eternal problem that is always raised when talking about the portrait. To what extent is likeness important? From an artistic viewpoint, is it a decisive factor? More than a categorical reply, what these questions provoke is further reflection on the problem. In the same way that a photograph can look very like the person being photographed without anyone thinking it is a valuable work of art, a portrait with a strong likeness of its subject can lack artistic value. No one can be sure of the likeness achieved in the great masterpieces of classical portraiture, although one can suppose that it was sufficient to satisfy the powerful patrons who had commissioned the works. In many of Rembrandt's self-portraits we recognize the same person, but there are no two faces that are identical. Each of these works has its own distinct intentions and coherence. This is one of the crucial points in the discussion: in all pictorial works of art, the artistic quality should come foremost; this is the fruit of an intention that cannot be subordinated to a faithful reproduction of the facial features. The conclusion to which one is drawn is that the portrait must maintain a balance between likeness and personal expression. When one of the two factors acts to the detriment of the other, the portrait suffers, either as a representation linked to a certain individual or as an artistic work in its own right.

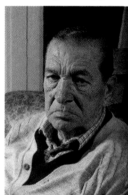

Resolving the problem of likeness in a portrait is a matter of observation and mastery of pictorial media.

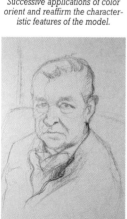

Successive applications of color orient and reaffirm the characteristic features of the model.

The features must be matched to the model's physiognomy before applying color and shaping the form.

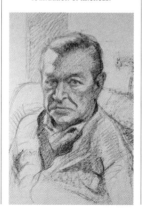

Shade and modeling respect the initial framework, which has already established the foundation of likeness.

How to Achieve a Good Likeness

There are three factors to be taken into account when attempting a good likeness. The first is the correct construction of the head. This factor is fairly independent of the characteristics of the particular model. There are anatomical constants, already considered in previous pages, which determine the form of the head and the situation of the face and feature on it. In the second place, it is necessary to find a certain exaggeration or emphasis of the characteristic features of each person. By doing so the artist is repeating a subconscious process that everyone performs when recognizing someone:

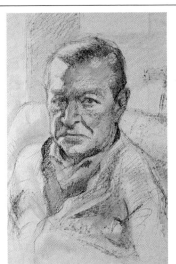

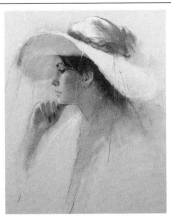

The result culminates in defining the eyes, nose, mouth, and lines of the face, which finally give the portrait character.

Joan Martí, Portrait. Private collection. The need for likeness can go hand in hand with the elegance and smoothness of the treatment.

individuals are very similar to one another; what is essentially different is the viewer's observation of certain distinctive features by which that person is known. For this reason, exaggerating the characteristic features is not a departure from objectivity but rather the opposite, a step towards the truly human psycho-logical act of recognizing fellow humans. In the third place, it is necessary to pay attention to the characteristic pose and gestures of the model. Each person has a different manner—some of physical characteristics, others of psychological characteristics—which the artist should identify and bring to the work.

These factors are never dissociated from one another. Once the artist begins to work, he or she will realize that they are closely linked and that resolving one of them requires resolving them all.

Synthesis

The power of synthesis is an indispensable skill for all artists, but especially for the portraitist. Details are always essential factors for achieving likeness. However, if these details are not subordinated to the whole, it will never be possible to achieve the essence of a living person, only to produce a series of characteristic aspects. Synthesizing means observing the model, understanding his or her physical characteristics, and developing from them a pictorial whole that integrates them coherently.

Synthesis of form is a precondition in all painting; it is even more so in the art of the portrait, in which expressive unity is the primary objective.

Psychological Likeness

As important as watching and observing the face, expression, and look of a model is knowing a person well enough to discover the best way of representing his or her face and character, using, for example, suitable lighting, a suggestion for pose, and a particular exaggeration of the features. To achieve good results the physical observation of the model is just as important as the knowledge of his or her psychological attitude.

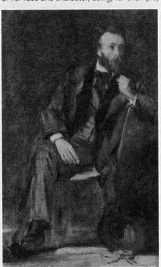

Edgar Degas (1834–1917), Portrait of Gustave Moreau. Gustave Moreau Museum, Paris. To achieve a psychological likeness the artist can start with one of the model's characteristic poses.

MORE ON THIS SUBJECT

· Basic Structure of the Head **p. 30**
· Characterization **p. 78**
· Composing a Portrait (I) **p.42**

EXPRESSION

CHARACTERIZATION

Characterizing consists of identifying and isolating the specific features that physically distinguish one person from another. These features can be composed of a few particularities that alone manage to express likeness. To achieve a suitable likeness, the artist must produce studies and sketches until he or she discovers which are the most significant aspects of the face and pose.

Basic Features

All good characterization begins with the identification of the basic features of the model. Not only must the artist see and understand the form, position, and proportion of the head in relation to the trunk, the face in relation to the head, and the features in relation to the face; it is also necessary to discover which of those features best identify the person. Each physiognomy has certain aspects that are, in some respect, "indifferent," that do not determine personal expression or clearly distinguish one person from any other. Although not obvious at first sight, this can be discovered after careful observation and after producing sketches and partial studies of the facial features. If the artist attempts a portrait without having produced these initial studies, he or she will doubtless waste a lot of time on insignificant aspects that contribute little to the characterization. The basic features are usually things like the chin, the form of the face (whether it is more rectangular or more oval), the height of the eyebrows, or any other factor that we normally think of as secondary.

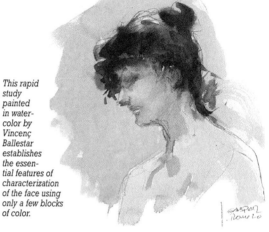

This rapid study painted in watercolor by Vincenç Ballestar establishes the essential features of characterization of the face using only a few blocks of color.

Initial Sketches

All good characterization has to begin with one or more initial sketches that determine the typical features of a person. These sketches should be produced starting with groups of strokes and simple forms that establish the proportions and basic dimensions of the head and face. For a person with a high or prominent forehead, it is a good idea to emphasize this undifferentiated area by placing the facial features lower down in relation to the curve of the skull. If the model has a prominent chin, the lines should be firm in this area. The distance between the eyes is a very indicative factor in characterization; within the constant proportions of the human head, if the separation of the eyes defines a likeness well, it should be emphasized (with eyes that are wide apart or very close together). Another aspect that might be important could be the length of the neck, the width of the face, and the greater or lesser visibility of the ears.

Simplification

During the work of characterization of a portrait, there comes a moment in which a likeness is achieved. The question that must then be asked is whether to

Characterization can be achieved both through facial features and through the depiction of a figure's characteristic gestures. In this work by Ballestar, the artist has adopted the second option.

MORE ON THIS SUBJECT

- Pose p.50
- Gesture p.52
- Likeness p.76

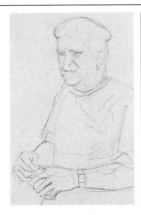

Characterization should be established in the first stages of work.

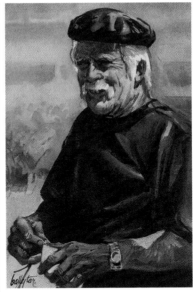

In the finished portrait by Vincenç Ballestar, the characterization of the figure has been maximized thanks to the appropriate articulation of the drawing and the elaboration of nuances in the colors.

Working with color can highlight the characterization of the figure.

continue the characterization or not. Generally, the accumulation of details on a good characterization leads to over-drawing of the likeness and returns the portrait to the initial point of lacking determination. For this reason, it is better not to take the characterization too far. To control these factors it is best to have a simple structure at all times: if the mouth can be expressed with two lines, it is always better not to use three. Only when the artist stops to inspect the whole result can he or she decide if it is necessary to continue adding aspects of detail or, on the other hand, come to the conclusion that what has already been done is sufficient.

Characterization Through Pose and Gesture

Not only the features are objects of characterization; pose and gesture can also characterize a person. This is shown daily when one recognizes someone's way of walking or sitting down. These aspects can also be used by the artist to complement the general characterization of the portrait. For this reason it is very important, when giving the model instructions, to insist that he or she adopt a familiar pose, one that is comfortable and in which the artist can see evidence of their knowledge of that person. In any case, gesture and pose should be natural and above all comfortable for the person being portrayed.

Learning from the Classics

To practice characterization in a portrait, it is also interesting to attempt to characterize various figures painted by the great masters. This exercise has the advantage of exercising one's ability for observation and synthesis, at the same time as it leads to a greater understanding of and appreciation for the work of these artists.

Jan Gossaert (1478–1553), Elderly Couple. *National Gallery, London. This is a work in which the painter has maintained the objectivity of the scene and at the same time emphasized the characteristic features of the figures.*

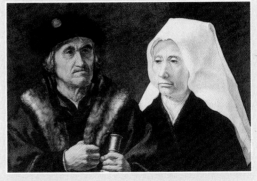

EXPRESSION

CARICATURE

Caricature is a useful way of achieving characterization and likeness. A good caricature is an exaggerated summary of all the observation and synthesis of which the artist is capable. Producing caricatures is one of the most useful and effective exercises possible for any portraitist. It is an excellent technique for beginning a portrait.

Exaggeration

All caricatures consist of an exaggeration of the subject's characteristic features. For this reason, all caricaturists have to begin by skillfully capturing the characterization. The process of caricature consists of nothing more than what has already been described under the heading of characterization. Once the caricaturist has identified the features that are particular to a person, he or she exaggerates them in order to achieve a comic or sarcastic result. However, there are different levels of caricature, from the purely humorous to those that deserve to be considered works of art because of the coherence of their execution. This is the case with some of the painters of the twentieth century whose method is based on stylized distortion of the features in accordance with a congruous and carefully studied composition—for example, Modigliani, Chagall, and even Picasso. Caricature is always an act of freedom in the face of realist impositions, a declaration of independence of the portrait with respect to the model, and often an amiable vision of some typical aspect of human nature.

Caricaturing consists of exaggerating the features that define most clearly the physiognomy and character of the person being portrayed, with a comic or satirical aim.

Suppressions

Caricature is distinguished as much by what it exaggerates as by what it hides or suppresses. As with all good characterization, caricature emphasizes certain revealing aspects while overlooking others or leaving them undefined. The caricaturist is always very aware of the effect that certain manipulations will have on the physiognomy and knows which are the features to emphasize and which to ignore. All this is done with a view to expressing what he or she has already decided to achieve, for which reason caricatures are never really improvised. The artist makes a composition in his or her mind before starting to work, and then has already decided which aspects to highlight. Furthermore, in addition to the physical aspects, the caricaturist adds an exaggerated characteristic expression and reinforces the emphasis of the features.

Media

The media for caricature need, of necessity, to be the most simple. The caricature that is pictorially elaborate, with light

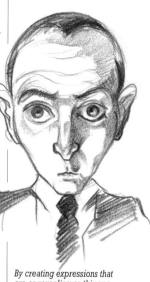

In addition to exaggerating characteristic features, a caricature usually suppresses or softens other aspects that are less indicative of the person being portrayed.

By creating expressions that are as revealing as this one, the caricature permits states of mind to be emphasized with greater efficiency than the realistic portrait.

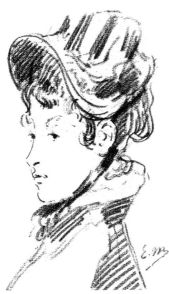

Manet (1832–1883), Mme. Jules Guillemet with Hat. *The Hermitage, St. Petersburg. The caricature is a form of portrait. In this example the exaggerations are dissimulated by the discretion of the execution.*

A. Le Petit, Caricature of Rufus Croutinelli. *Art Institute of Chicago. The caricature combines the dexterity of the artist with the wit of the humorist.*

and shade, with modeling and tonal values, and with adjusted skin tones, becomes unbalanced and loses its expressive force. This does not mean that a caricature cannot be made, for example, in oil. But when the pictorial elaboration gets in the way, the caricaturist must alter the traditional methods of portrait painting to adapt them to his or her ends, as can be seen in the works of the previously mentioned Modigliani, Chagall, or Picasso. In any case, caricature is an eminently graphic genre, which begs to be executed with simple media: pen, pencil, charcoal, and felt-tip pen. These are based on the stroke and the continuous line, without too much pictorial elaboration.

Mastery of Stroke

To draw effective caricatures, it is necessary to be able to master the stroke and to know how to achieve likeness and expression with just a few lines.

The line of the profile is one of the favorite resources of most great caricaturists for achieving their aims. This is because, compared to a face seen from the front, the profile contains much more significant information that can be expressed using a line. The face in profile, which shows protuberances and volumes of the features, can be drawn with a single, continuous line, without the need to use modeling or shading. For an expert caricaturist, a few lines and a few minutes of concentrated work are enough to achieve his or her aims.

Producing Caricatures

Producing caricatures does not require any of the preparations needed for painting a portrait of a model. The best exercise for a caricaturist who wishes to become practiced in this genre is to go out and depict the features and expressions of passersby as they come and go. This is how famous caricaturists like Toulouse-Lautrec worked, sitting and watching the strangest faces go past, and depicting them on paper quickly and mercilessly.

Eugène Delacroix (1798–1863), Sketch Book. *The Louvre, Paris. Great artists have drawn caricatures as a way of capturing people's physiognomies and movement.*

MORE ON THIS SUBJECT

· Gesture p. 52
· Likeness p.76
· Characterization p.78

THE PSYCHOLOGICAL PORTRAIT

Psychology manifests itself in gestures and above all in the face. Facial movements reveal the state of mind, and the only way the artist can represent psychology is through these movements. To understand the origin of all facial movements, the basic elements of anatomy described in earlier pages must be borne in mind and adapted to each individual case.

Elements of Psychological Expression

There are many factors that determine a person's psychological expression, but the artist can rarely count on anything other than facial and bodily expression to deduce the state of mind and also to portray it. The ability to observe and represent nuances of expression are the essential skills. Generally, artists who can notice and represent psychological factors best are also the ones who best treat the facial features and who are capable of subjectively reconstructing the interior condition of their fellow human beings. This reconstruction consists of nothing more than imagining what they think they see in others as a way of checking the subject's state of mind. More often than not, psychological expression consists of small details that combine to offer a convincing result: minor physical differences, nuances of

Francesc Serra, Portrait of a Young Man. Private collection. The capture of psychological state sometimes depends on details and subtleties of expression.

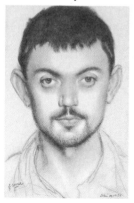

The combination of the forehead and the eyes provides a major component of expression.

The cheeks are the most mobile part of the physiognomy. They are involved in most expressions.

gesture, movements of the face that reveal psychological meanings overlooked by most people, but not by someone who is sensitive enough to "read" in faces the real significance of an individual's expression.

The Brow

The brow is one of the most revealing aspects of psychological expression. *Furrowing the brow* is a synonym for being worried, angry, or irritated. As always, a psychological expression is not the fruit of a single factor, but the result of a series of different aspects that combine together. Movement of the brow involves the eyes, eyebrows, and eyelids being screwed up as well; this is the

result of the contraction of the frontal muscles, which are the ones that cause lines on the forehead; at the same time these muscles pull directly on the orbicular muscles of the eyes. Anatomically speaking, it can be seen that there is no movement that is completely isolated.

The Cheeks

It is difficult to conceive of a facial movement with a psychological cause that does not affect the cheeks in one way or another. So many muscles meet here that there is almost always a direct or indirect effect from any facial movement. Only the isolated movement of the forehead is

The movement of the eyes contributes a great deal to the likeness of an expression.

Furrowing the brow signifies different states of mind.

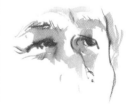

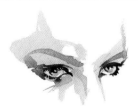

Achieving expression in the eyes might be enough to reveal the subject's psychological state.

completely independent of them. In the cheeks the zygomatic, maseter, risory, and buccinator muscles meet, to name just a few. Movements of contraction, elevation, dilation, and depression of the cheeks are very characteristic and can reveal different states of mind. The movement of the cheeks is directly affected by movement of the mouth, and vice versa. It is sufficient to make a few faces to see the wealth and complexity of the different relationships that exist between them.

Mary Cassat (1844–1926). Child's Head. Private collection, Paris. The expression of age is a fundamental characteristic of psychological portraiture.

MORE ON THIS SUBJECT

· Eyes and Eyebrows **p.32**
· The Nose and Ears **p.34**
· Gesture **p. 52**

The Lips

Movement of the lips shows each type of expression with unquestionable clarity. A few variations are enough for the observer to be able to interpret entirely contrasting moods: for example, laughing and crying. Between these two extremes,

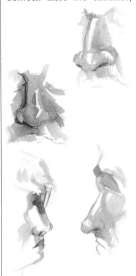

The nose and lips are involved in the most intense expressions.

there stretches a whole range of different psychological nuances. These are almost always linked to other muscles in the face, especially the cheeks. The lips' own muscle is the orbicular, but many other muscles act on it, most of them also responsible for the movement of the cheeks.

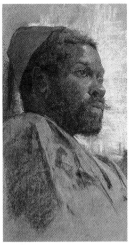

Marià Fortuny (1838–1864), Ferragi. Círculo Artístico, Barcelona. This work shows a detailed observation of the features and the psychology of the subject.

Light and Psychological Expression

In certain portraits, the treatment of light stands in for the facial expression of the psychological condition. Combining both factors (expressive light and articulation of the facial features) can lead to a disagreeable overload of expression.

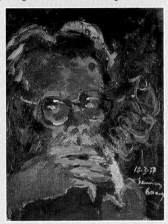

Sanvisens, Self-portrait. Private collection. Light, color, and all the artistic elements can overload a work.

SMILING AND LAUGHING

Smiling and laughing are different phases of a very similar muscular processes. The latter is a generalized extension of the movements that the former begins. In both, it is important to study the configuration of the mouth and lips, as well as the series of furrows and creases that appear both on the cheeks and the forehead.

Smiling

During a smile the effect of any muscles other than the risories and the larger zygomatics is minimal. Both muscles have the task of opening the lips by tensing them. As a result of this tension, an elevation at the ends curves the lips upward. Simultaneously, creases appear at the corners of the mouth. This movement is accompanied by other changes in other areas of the face, although with lesser intensity. The frontal muscles and the orbiculars of the eyes usually move the eyebrows and the forehead by lifting them, sometimes imperceptibly, although at other times creases appear on the forehead. They can also relax this area by making the eyebrows descend a little. The lower part of the orbiculars of the eyes contract, raising the lower eyelid and making a light crease in it.

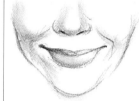

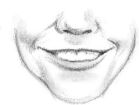

The smile and the laugh are expressions that resemble one another; the difference is one of emphasis.

laughter is due to the contraction of the zygomatic and major risory muscles. Thanks to the same contraction, the characteristic creases at each side of the mouth also appear. This movement can reveal the teeth and make the lips considerably thinner. The same contraction also puffs out the sides of the face and gathers the skin into creases below the lower eyelid. The eyes are half-closed, with the characteristic appearance of happiness that always accompanies a guffaw or frank laughter. This movement of the eyes creates creases at their edges. The forehead is also affected so that the frontal muscle contracts and furrows appear. In summary, it can be said that when someone laughs the corners of the mouth form a curve caused by the action of the major zygomatic and risory muscles. The upper lip, lifted and stretched by these muscles, moves upwards while the lower lip is curved. This displacement of both lips

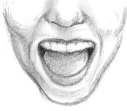

means that only the upper row of teeth can be seen. The characteristic creases of a smile, which appear on both sides of the mouth, are determined principally by the contraction of the major zygomatic muscles.

Relaxed lips always have greater volume than when they are smiling or laughing.

Laughing

A hearty laugh is one of the expressions that have the greatest effect on the muscles of the face as a whole. Almost all of them are tensed in some way, either lifting or lowering, forming bumps and creases over the whole face. The appearance of the mouth during

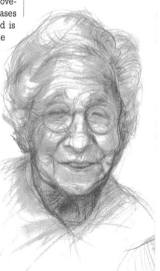

The smile is a gesture in which almost all the muscles of the face are involved.

An open smile reveals the teeth. The artist should avoid marking the separations between them.

A smile creates characteristic furrows at the corners of the mouth and on the cheeks.

MORE ON THIS SUBJECT

- The Mouth and Chin **p.36**
- Foreshortenings of the Face **p.40**
- Gesture **p.52**

Smiling, laughing, and guffawing are three manifestations of a very similar expression. There are as many variations as there are possible physiognomies. However, the muscular movements that appear in these expressions are the same and cause similar results.

Forced Expressions

When an artist practices expressions in front of a mirror in order to study and sketch them, the result might appear forced because of the wish to represent all the movements exactly. To avoid this problem, the best course is not to force the expression too much, and not to push it to its limit, so as not to end up with a mask or a grotesque expression.

Copy of a drawing by Leonardo de Vinci. Leonardo had a perfect knowledge of anatomy and facial expression.

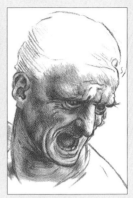

Guffaws

In a guffaw the same muscles that were mentioned concerning laughter are involved, but with greater contractions. The eyebrows rise much more, although lines do not usually appear on the forehead. The opening of the mouth tends to form a circle that reveals both rows of teeth, the upper much more than the lower. Deep furrows appear on the cheeks in the form of an arc that makes the shape of the mouth even more extreme.

STATES OF MIND (I)

This chapter begins a series of partial studies of expressions that are caused by moods of all types, from happiness to melancholy, from enthusiasm to fear, as well as pride, envy, and effort. These expressions are products of the movement and tension of specific muscles or groups of muscles; each one is capable of a wide range of possible variations.

Sadness

From an anatomical viewpoint, sadness involves muscular relaxation—a state in which the only muscles that have any degree of tension are the obiculars of the eye, which cause the movement of the eyebrows, and the elevators of the upper lip. The relaxation of the muscles causes a fall in the corner of the mouth, while the muscles that surround the jawbone also relax, making the cheek appear stretched. In contrast, the contraction around the eye pulls the brow inwards and makes it furrow slightly.

Melancholy

Melancholy, which resembles sadness, also involves a general relaxation of the facial muscles. However, it creates a somewhat different expression. This odd look consists of a slight lifting of the eyebrows, while the half-closed eyes produce tension in the upper eyelid. The mouth

Sadness and grief are characterized by a relaxation of the muscles of the face and a static expression.

This type of expression can underline the gestures and pose of a figure to give it an unambiguous meaning.

remains closed or almost closed, and the relaxation of the muscles creates a slight fall of the lower lip. On the forehead appear a few lines caused by a lifting of the eyebrows. But one of the factors that best characterize the expression of melancholy is the slight tilting of the head, as if it has been stopped as it was about to fall, and above all the lost look that the half-closed eyelids emphasize.

Extreme grief tenses the muscles of the cheeks by moving the lips upwards in a characteristic expression of the mouth.

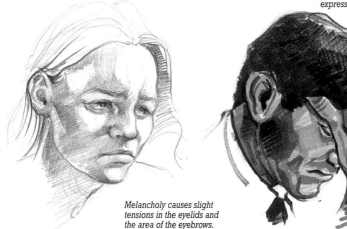

Melancholy causes slight tensions in the eyelids and the area of the eyebrows.

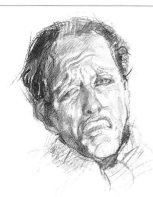

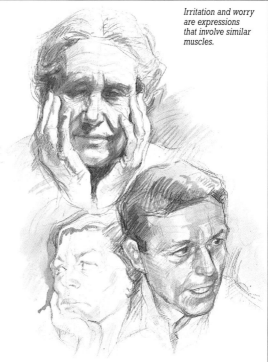

Irritation and worry are expressions that involve similar muscles.

MORE ON THIS SUBJECT
· Characterization **p. 78**

Worry and Irritation

Worry is usually expressed by a furrowing of the brow and a joining and lowering of the central part of the eyebrows. The mouth remains rigid and horizontal, in some cases emphasizing the bulge of the masseter, which keeps the mouth shut. When the mouth remains firmly shut, the face expresses irritation.

Pride

Pride, disdain, smugness, and scorn are characterized by "looking down one's nose." This can be translated graphically by a raising of the eyebrows (sometimes one more than the other), a lowering of the upper eyelids, a slight raising of the head (which tilts a little backward), all accompanied by a sneering of the mouth (out of disdain or pride), which is mainly caused by the contraction of the triangular muscles that pull the corners of the mouth downwards, while the center of the lips rise slightly.

Pain

Physical pain is expressed by a slight opening of the mouth, or a furling of the lips with the mouth tightly closed. When the lips form an arc, as in the masks that symbolize tragedy, all the muscles that surround the mouth

are involved, particularly the minor zygomatics, which contract and pull the middle of the upper lip upward and outward. This strong contraction forms two folds at both sides of the mouth, thus outlining heavy creases below and next to them, helped also by the orbicular muscles of the eyes. These remain half-closed, but tensed, putting a

large number of creases above, below, and beside them into relief. The orbicular muscles also furrow the brow, crossing it with creases that augment those produced by the frontal muscle.

Contained Emotion

Anger and sadness can be emotions that are contained and do not allow themselves to be expressed by obvious gestures. The painter can capture these states of mind using nuances of the look and expression of the mouth.

Josep Puigdenolas, Adela. Private Collection. Irritation can be a contained emotion, as expressed in this work.

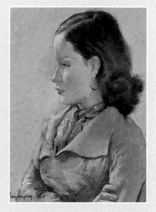

STATES OF MIND (II)

The intensity of our states of mind is expressed through different tensions in the facial muscles. With the most intense and extrovert moods, gestures tend to be similar, and are only distinguishable through nuances and differences that are very understated. Happiness, shouting, singing, effort, and enthusiasm are some of these states of mind.

Happiness

The expression of happiness combines all the anatomical characteristics mentioned with reference to laughter, but includes other more subtle and elusive aspects of muscular activity. In general, happy expressions tend to involve an upward movement of the eyebrows and an opening of the eyes. The facial characteristics appear more relaxed, without excessive tension, and for this reason do not form furrows or lines. The expression of happiness is usually associated with smiling: a lateral tension lengthens and narrows the lips without separating them. Normally a smile does not tense the lips symmetrically, but moves them to one side of the face or the other. In any case, happiness is an expression that never causes a distorted face, for which reason one should avoid exaggeration and not highlight the features too much.

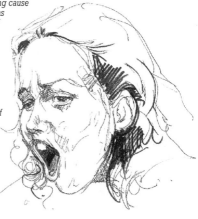

Shouting and singing cause extreme expressions that tighten most of the facial muscles. The tense eyelids half close the eyes and the cheeks reveal their full volume. The opening of the mouth is the most significant aspect of these expressions, which on occasion can take on a theatrical appearance.

Shouting and Singing

In extreme expressions like shouting, the same facial configurations can be interpreted as the manifestation of opposing states of mind: desperation or euphoric enthusiasm. With shouting, the mouth opens as wide as it can, showing the teeth and tongue; the facial muscles are tensed, creating vertical furrows on the cheeks and accentuating the volume of the cheekbones. The eyes are half-closed and creases appear on both sides of the eyelids. The eyebrows furrow downwards and inwards in a violent contraction that affects and lines the forehead, the brow, and sometimes even the point of the nose itself.

Singing cannot be considered a variation of shouting, but it has some characteristics in common with it, above all with regards to the opening of the mouth. However, in singing the features do not tense up violently, but rather adopt a lightly theatrical appearance. The eyebrows arch and all the tension is concentrated in the eyes, which are the vehicles of greatest facial expression.

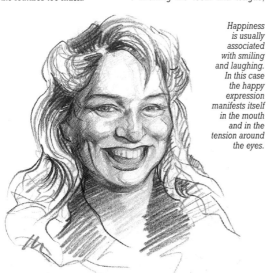

Happiness is usually associated with smiling and laughing. In this case the happy expression manifests itself in the mouth and in the tension around the eyes.

MORE ON THIS SUBJECT

- Gesture **p.52**
- Characterization **p.78**
- The Psychological Portrait **p.82**

Effort

The expression of effort is manifested in various tensions of the facial muscles. The most visible of these is in the knitted brow and the lines on the forehead caused by it. Effort is usually manifested in a strong contraction of the muscles of the jawbone, a "clenching of the teeth," which is usually visible in the male face through the slight prominence of the rear part of the chin. Similarly, the lips are usually clenched or, at any rate, pressed together and reduced within the general appearance of the face.

Human facial expressions that characterize a situation of force are demonstrated by an expression of concentration, accompanied almost always by the tightening and tension of the muscles of the neck.

Effort, which can involve the whole body, also manifests itself in the muscles of the face through the knitting of the brow and a clenching of the lips.

Expressions and Portraits

The representation of violent or intense expressions is not usually associated with the art of the portrait. In these types of characterizations the artist looks more for expressiveness of the facial gesture than for likeness. It is helpful for the artist to start with his or her own face in different expressions, working in front of a mirror or using photographs from newspapers, magazines, or books, and then elaborating the sketch according to taste.

William Hogarth (1697–1764), The Prawn Seller. National Gallery. This shows the perfect capturing of an expression, with all the nuances fully developed.

Enthusiasm

Like laughter or happiness, enthusiasm is an essentially extroverted expression, which is usually accompanied by a raising of the eyebrows, a somewhat exaggerated opening of the eyes, and a smile. It is an expression that involves a certain posture of the body that expresses outwardly the vitality and lack of inhibition of the mind. Like laughter and happiness, enthusiasm can be represented by marking the basic characteristics of the eyes and eyebrows, suggesting the smile but without emphasizing too much the particular tensions of the facial muscles.

Enthusiasm causes a raising of the eyebrows and the opening of the eyes and mouth.

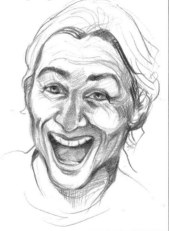

STATES OF MIND (III)

This series completes the study of the facial expression of states of mind. Here the expressions of fear, terror, hatred, anger, and envy are considered. Each of them has its own physiognomic particularities and its characteristic features. This study could be extended to many other expressions, although most of them are variations, more or less sophisticated, of those considered on these pages. The artist interested in representing expressions should follow his or her curiosity and investigate the nuances and peculiarities which give each its characteristic expressiveness.

Fear

In the expression of fear the eyes open more than normal, lifting the eyebrows at the same time, while the mouth seems to shape itself to make an exclamation. Eyebrows and eyes are easy to draw: the former are arched upwards and slightly knitted at the brow, showing the worry that goes with fear. The eyelids should be drawn more open than normal, allowing the white of the eyeball to be seen, with the iris and pupil standing out in the center. In the expression of fear the mouth opens in a static manner, forming furrows on the cheeks, making them rounded, and pulling the corners of the mouth down.

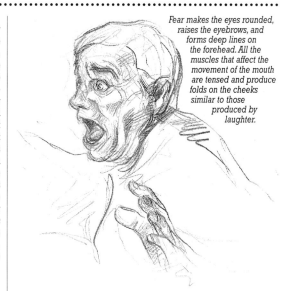

Fear makes the eyes rounded, raises the eyebrows, and forms deep lines on the forehead. All the muscles that affect the movement of the mouth are tensed and produce folds on the cheeks similar to those produced by laughter.

Terror

Terror, a form of exaggerated fear, is usually accompanied by a shout or exclamation. The eyes should appear to pop out of the head, being open as wide as possible due to the violent contraction of the orbicular and frontal muscles, which pull the eyelids and eyebrows upwards, raising them and creating deep lines on the forehead. All the muscles of the mouth react, especially those of the lower part, which reveal the teeth. The sides of the nostrils dilate, creating lines that recall those formed in laughter.

Hatred

This is generally a contained, introverted passion, which can nevertheless be translated into a facial expression. When drawing this expression, it is necessary to think about the tense clenching

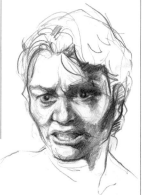

Hatred, usually a contained passion, is manifested in a tension of the muscles of the jaw, mouth, and brow.

of the jawbone that accentuates the bulge of the muscles of the chin. The mouth is also closed, creating a horizontal line. The lips narrow, and the corners of the mouth are pulled slightly downward. Above, the eyes have a blazing expression (the eyes are slightly more open than normal) darkened by the horizontal rigidity of the eyebrows, which should be located as low as possible and with the brow slightly knitted.

Anger

Exasperation, explosion of temper, and anger are revealed by the same movements as hate in a more advanced state. The eyelids open to reveal the eyes, the eyebrows are raised, the brow is knitted, and the forehead is furrowed with lines. The mouth

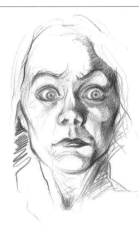

Anger tenses the muscles of the eyes and makes them open more than usual, while the muscles that surround the lips contract violently.

opens and the jawbone moves forward, while all the muscles that surround the lips contract violently.

When expressing anger or temper, the jawbone juts slightly outward, moving the lower part of the maxilla. The lower lip

MORE ON THIS SUBJECT

• The Psychological Portrait **p.82**
• States of Mind (I) **p.86**
• States of Mind (II) **p.88**

folds outward, contracted by the muscle of the chin. At the same time the muscles of both sides of the corners of the mouth pull strongly downward, while the upper lip moves upward through the action of the muscles located in the base of the nose. With the mouth almost closed, the face "shows its teeth" in an expression of ferocity. The sides of the nose dilate extraordinarily in any state of violence. The deep lines on both sides of the mouth create creases below the eyes. These, however, stay more open than normal, allowing the pupil and iris to be seen.

Envy and distrust are expressed with a light pursing of the lips and above all by an evasive look of the eyes.

Envy

Envy, jealousy, and lack of confidence are expressed by a folding in the lips, which narrows their profile, while the wings of the nose are tensed, making the nostrils wider than usual, and the eyes, with the eyelids falling a little, peer from their corners. It is precisely in this look that the expression of envy is centered.

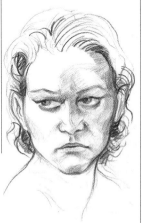

Studies and Variations

Studies of facial expressions, which an artist might make by working in front of a mirror, allow for all types of variations. Starting with an expression, it is interesting to modify some feature or other, to intensify the folds and creases, to open or close the eyes or mouth in order to experiment with new gestures and attitudes. In this way it is possible to discover unforeseen expressions that differ from the characteristic prototypes and which enrich the expressive repertory of the artist. The brow, the lips, and the teeth are usually the areas where the expression of exasperated emotions is displayed. The artist can practice drawing these expressions in front of a mirror, studying his or her own face.

Exasperated expressions in which all the muscles of the face appear tense.

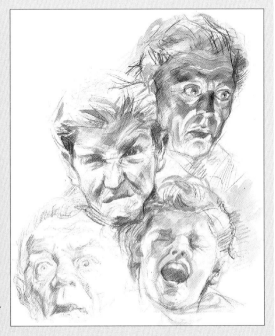

HAND GESTURES

Hands are a fundamental source of expression, not only in portraits but also in illustrations and caricatures. Hand gestures accompany facial expressions, reinforce them, and on occasions can even substitute for them. The hands say a lot about the temperament of the portrait's subject, as well as about the psychological instant that the artist is trying to portray. Anatomical knowledge and an understanding of the logic of how the various movements are articulated is essential to give hand gestures their full expressiveness.

Drawing Hands

Hands are anatomically complicated, which is why it is very important when drawing them always to produce a framework of the overall volume they occupy before then filling in the detail of the fingers and palms. Bearing in mind the proportions and anatomical relationships of each of the parts is also essential. The bones of the hands affect their outward appearance and are very visible beneath the skin. The large number of bones should always be related to the wrist and the knuckles. To simplify the framework, it is important that the knuckles and joints of the fingers correspond to a proportional distribution that must be maintained regardless of the position they are in. The best possible exercise for the artist is to use his or her own hands as a model and to study them in all the positions possible.

The drawing should always start with a general outline before moving on to filling in the details.

Movement

Given the complexity of their articulation, the movement of the hands is extremely varied. This variety is always governed by the logic of the arrangement of the fingers, their link with the palm, and the movement of the palm in relation to the wrist. Nevertheless, the hands should always be considered an extension of the arms, which move in the same direction. Only after having resolved this factor can one introduce the movements specific to the wrist, palm, and fingers. One of the most interesting studies consists of drawing hands together, either intertwined, one on top of the other, or in an odd gesture or action. Using studies like this, the artist will come to understand the hands' anatomy and natural movement.

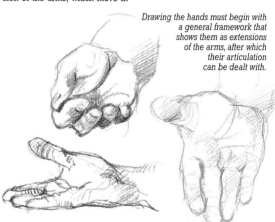

Drawing the hands must begin with a general framework that shows them as extensions of the arms, after which their articulation can be dealt with.

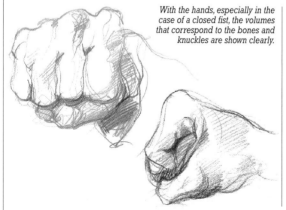

With the hands, especially in the case of a closed fist, the volumes that correspond to the bones and knuckles are shown clearly.

Expressiveness

After the face, the hands are the greatest factor in the expressiveness of the portrait. Because of their mobility and the significance the viewer attributes to their gestures, the hands say a lot about the character and psychology of the portrait's subject. They can rest in the lap or be engaged in some activity, or they can be holding some object or be entwined with one another. The passivity, worry, nobility, or character that the face sometimes hides can be revealed by the hands. Their

Everyday Gestures

It is important to observe and remember everyday gestures that could be incorporated in a portrait to give a work greater human resonance. An artist might observe some of the everyday gestures assumed by the model; when the model is posing, the artist can then ask him or her to adopt one of these gestures in order to achieve a more habitual or natural position. The way of holding a book, a cigarette, a glass, or any other object, the action of sewing, writing, or playing cards are veritable artistic themes in themselves.

Mary Cassat (1844–1926), Woman Sewing in a Garden. *Musée d'Orsay, Paris. The occupation of the hands engaged in daily tasks provides plenty of pictorial subject matter for the artist.*

position should always be in tune with the rest of the pose and should form a harmonic part of the general composition of the figure.

Before the artist concentrates on the elaboration of the hands, the foundation of the work should be homogenous; the congruence of all the parts is what determines their position and gesture. Trying to give them priority over the whole will lead to artificial and unconvincing results. It is necessary to remember that in compositional terms the hands are rather unimportant appendages to the body as a whole.

Gestures

In illustration and caricature, hand gestures are the best complement to expression. There are many expressions of the state of mind that can only be fully depicted if they are accompanied by a movement of the hands. It is in this type of drawing that one can make the maximum use of a thorough knowledge of the

hands' anatomy and articulation. Sometimes the expressiveness of a movement of the hands is so indicative of a state of mind that a facial expression is barely necessary.

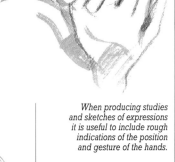

Hand gestures are a perfect complement to expression: they underline it and sometimes add nuance, giving it a more complete, realistic feel.

When producing studies and sketches of expressions it is useful to include rough indications of the position and gesture of the hands.

MORE ON THIS SUBJECT

· Gesture **p. 52**
· Characterization **p. 78**
· Body Gestures **p. 94**

BODY GESTURES

The expressiveness of the gesture, when elevated to the level of movement of the whole human body, goes beyond the limits of portrait and characterization and becomes part of global artistic expression. Psychological meaning can also be expressed using the expressiveness of the body, but it is particularly factors of energy, vitality, and sensuality that best lend themselves to being articulated through the movement of the entire body.

Energy

Effort, strength, or muscular power are some of the recurrent motifs of figures in painting throughout history. The human body as a whole can suggest states of mind, including some as explicit as vitality, for example. Figures running or dancing give the viewer a sensation that no psychological characterization of the portrait could achieve. The harmonious poses of dancers express musical rhythm by transferring it to the rhythms of the muscles and to the counterpoints between arms and legs. Another recurrent motif is that of wrestlers in full combat, their muscles tensed to their absolute maximum. Captured in positions of momentary balance, the strength of each of the combatants is countered with all possible tension. Physical work also offers the artist plenty of thematic possibilities: figures heaving heavy weights, pulling

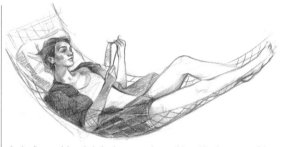

In the figure of the whole body, gesture is conditioned by the nature of the pose. In this case, a static pose does not encourage an intense gesture.

or pushing them, or pressing them with their hands and feet in a way that no conventional pose would resemble.

The Nude

The art of the nude can only receive a brief mention in a book dedicated to the portrait, although it is impossible to avoid it when talking about the emotional impact of the body. The nude is the summary and synthesis of all the expressive-

ness that can be found in the painting of figures. Paintings of nudes usually repeat recurrent motifs: energy, sensuality, passion, and beauty are the most common. These themes may be too generic and abstract to discuss from the point of view of characterization in the same way as the portrait. Similarly, in the nude, likeness is relatively unimportant because the artist is trying to symbolize a generic feeling by means of the harmony of anatomical forms.

The pose of an entire body portrait can imply psychological content, independent of the features of the face and gesture.

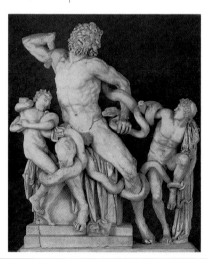

Sculptural Group of Laocoon. *The Louvre, Paris. This is one of the classical models for physical expression involving contortion and muscular tension.*

Portraits of the Entire Body and Gesture

The possibilities for bodily gestures in portraits of the entire body are limitless. The portrait is usually a realistic genre that aims at likeness and authentic characterization of the subject, for which reason there is little room for exaggerated gestures and brusque movements. However, there is the possibility of endowing a figure with movement and attitude to give it greater interest than would be achieved with a passive pose. In this respect one must mention the poses in which a figure is caught while performing a habitual action, such as turning the body and head towards the viewer, lying back in a chair, or looking through a window.

Corporal dynamism can express a state of mind perfectly, if it is captured with speed and sharpness.

Mimicry

Mimicry involves the intensification of an expressive gesture of the human body. Certain people have a spontaneous tendency towards this type of gesture, which makes them very expressive. This can be reflected in a portrait of characterization, in a caricature, or in an illustration. In these works the movement of the hands and the rest of the body is just as important as the facial expression. The best results are achieved

Classical Gestures

Most models for the gesture of the human body in Western art come from classical art. Greco-Roman reliefs and sculptures have been part of the essential repertory of many generations of artists, who have copied them and provided hugely varied versions of them. The movement of these figures always contains a characteristic nobility, harmony of gesture, and rhythm that accord with their monumental conception. There is nothing everyday or realist about them. However, the artist can be inspired by them to produce versions that suit his or her particular interests.

In this copy of a drawing by Rubens the typical gesture of a body in classical art is perfectly portrayed. It is a gesture based on the traditions of Greco-Roman art.

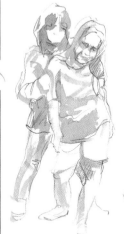

The movement of the body always contains suggestions of character and state of mind.

by isolating the figure from its surroundings and concentrating on the body, without secondary factors that might attract the attention of the viewer toward elements other than the figure.

MORE ON THIS SUBJECT

• Composing a Portrait (I) **p. 42**
• Pose **p. 50**
• Gesture **p. 52**

Movement or dance are among the most expressive forms of body gesture.

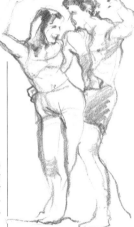

Original title of the book in Spanish: *Retrato Rostros y Expresiones.*
© Copyright Parramón Ediciones, S.A., —1998 World Rights
Published by Parramón Ediciones, S.A., Barcelona, Spain

Author: Parramón's Editorial Team
Illustrators: Parramón's Editorial Team

Copyright of English edition by Barron's Educational Series, Inc., © 1999

All inquiries should be addressed to:
Barron's Educational Series, Inc.
250 Wireless Boulevard
Hauppauge, New York 11788
http://www.barronseduc.com

Library of Congress Catalog Card No.: 98-74719

International Standard Book No. 0-7641-5108-8

Printed in Spain
9 8 7 6 5 4 3 2 1

Note: The titles that appear at the top of the odd-numbered pages correspond to:

The previous chapter
The current chapter
The following chapter